TURN TO THE SUN

YOUR GUIDE TO RELEASE STRESS
and CULTIVATE BETTER HEALTH
THROUGH NATURE

BRITTANY GOWAN

To Marnie, my mom and muse.

ISBN 978-1-4002-4373-0 (audio)
ISBN 978-1-4002-4374-7 (epub)
ISBN 978-1-4002-4372-3 (HC)

Printed in Malaysia

24 25 26 27 28 OFF 5 4 3 2 1

CONTENTS

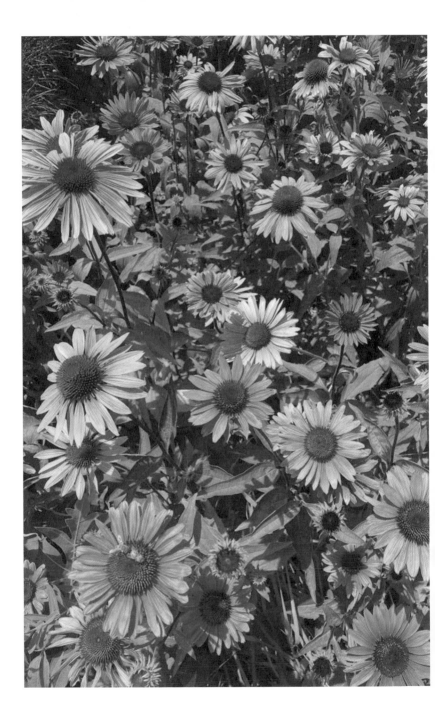

PLANTING
THE SEEDS

B *REATHE IN NATURE AND BREATHE OUT STRESS.*
This simple yet powerful mantra is the foundation of my nature-centered approach to mindfulness.

With the natural world as our teacher, we're about to embark on a journey to learn to manage stress, bring healthy balance to our lives, and respond thoughtfully to changes and challenges. By applying the lessons that nature shares, we'll be well-equipped to better deal with stressors and cultivate a healthy and happy nature-centered life. Our path to growing well starts by taking an intentional pause to connect with ourselves and the natural world.

While nature isn't hidden, she's so generously ever-present that our eyes and thoughts may cruise straight past her. But with a heightened awareness of our surroundings, we'll learn how to see and appreciate evidence of nature's gifts almost everywhere.

When we focus our gaze purposefully on greenery, we can behold the delicate beauty of a single leaf and hear the rustle of branches in the passing wind. With intention and an open mind, we can become rooted in the natural world, which has much to teach us.

To begin, we need only to show up. The deliberate act of arriving indicates what we value, and what we value affects what we're able to receive. Once we commit to interacting with the natural world, it will continually show up for us in return.

Nature lives in the present—bursting forth in wide, open-aired vistas and in silent strength sprouting through the concrete cracks of city sidewalks—and when we connect with it, nature grounds us in the present. When we pause in the company of our living world, we create healthy mental and emotional space to release unwanted emotions and better relate to the environment, others, and even ourselves.

Connecting with the natural world is now an instinctive practice that steadies the rhythms of my daily life, though my kinship with nature began in childhood. An adolescent love of feeling the cool, dewy grass beneath my bare feet, gazing dreamily up at the billowy clouds overhead, and seeking out the sun's warmth as much as possible has grown into an intentional practice that makes me an ongoing student of the natural world. Nature's bounty will never stop growing; in turn, I can trust that I won't either. I still turn to nature when I feel happy, when I need guidance, and when I need a burst of energy or soothing relief.

With my gratitude for greenery ever present, I'm delighted

to accompany you on a plant-filled journey to a more peaceful, positive mindset. This book is designed to help you slow down, pause, reflect, and connect. Release the inclination for a quick read. Instead, take your time and mindfully traverse this text at your own pace, ideally allowing for each practice to become integrated and embodied. Along the way, I'll share affirmations, meditations, and how-tos to deepen your practices and nurture the integration process. Consider these your personal gardening tools to grow well. This book is structured as a guide to establish, grow, and nurture your nature-based wellness practice, but the individual exercises are designed to be revisited anytime you need to fill a specific need.

> THIS BOOK IS DESIGNED TO HELP YOU SLOW DOWN, PAUSE, REFLECT, AND CONNECT.

- AFFIRMATIONS are simple statements that act as empowering mantras and have a positive effect on our thoughts and actions. These will consist of short, declarative statements that are typically written in first person. Don't be afraid to recite them out loud and feel ownership of their meanings.
- MEDITATIONS provide guidance for reflection and contemplation to center the mind and body and reach a heightened level of awareness. These sections will guide you on journeys in your mind's eye, revealing the powerfully positive effects of intentional thought practice. Consider reading them in a quiet setting to limit distractions.

- **HOW-TOS** share actionable exercises to help you practice fully engaging with the natural world and to grow a sustainable connection.
- **PHOTOGRAPHY** offers a visual path to a stronger connection with the natural world.

For each exercise, adopt a straight posture, relax your hands, and breathe in and out slowly and evenly. As other thoughts contend for your attention, pause to notice their arrival, then usher your mind back to the exercise and present moment.

These affirmations, meditations, and how-tos are intended to help you strengthen your personal connection with nature. Think of this book as both a guide and a companion to your unique journey. At any moment, day or night, you can open up to a page, focus on your breath, and pause to experience the restorative qualities of the natural world.

MY NATURE-CENTERED PATH

While I was growing up in Central New York, nature was an active and present component of my childhood. Trees and plants surrounded my home, their greenery creating a backdrop for my imaginative adventures. From the crisp onset of autumn to the first fresh breath of summer's warmth, I was raised to celebrate the changing seasons. Beginning at an early age, the colors created by the natural world captivated my attention. As a bright green leaf

faded to yellow and then fell to the ground, I found the mustard color to be just as remarkable as the green that came before. My fondness for nature reflects my parents' love and appreciation for all elements of the environment. They would point out the first crocuses of spring, fluorescent-green moss growing on a tree trunk, coral impatiens in full bloom, and hollyhocks growing at the edge of a country road. Before long, their lessons became the way I related to the natural world.

My parents, Marnie and Bill, dedicated hours in our yard preparing flower beds for the summer season and tending to lush ferns and hostas on the landscaped islands that connected our maple trees. Throughout the years, they propagated dozens of plants, creating a sea of greenery below the trees. The nature around our home was wild but nurtured—and plentiful! Looking back, I realize the many ways this natural setting provided a sense of calm and tranquility. Whether I was outside in our yard or gazing out my bedroom window, it was easy to feel the presence of the natural world.

Sharing the various ways we noticed nature was a common topic of our family conversations, and it became an essential way we managed incoming stressors and maintained a positive outlook. I didn't entirely understand the significance of my connection to nature until I moved from our home in the lush landscape of Central New York to live in New York City.

I moved to Manhattan for every reason that didn't include my love of nature. Having studied photography, I was attracted to the city's architecture, urban lifestyle, and scale. It was evident to me

within the first year of settling into my new home that New York City and nature lived as neighbors at the intersection of my emotions. I've experienced awe when observing buildings enhanced by Beaux-Arts or cast-iron design, felt alive and happy while witnessing unique experiences, such as a Broadway musical or the New York Yankees winning in the playoffs. I continue to feel both hopeful at the opportunities a major city offers and humbled by the grandness of Gotham.

To this day, living in the city still energizes my soul. I can always find inspiration in the miles of concrete sidewalk, a resolute witness to a history of millions of people on the move. But what I didn't foresee when I moved to Manhattan was my elemental need for nature and where I might find it, even beyond city parks.

There was a growing spark inside me to explore, in tandem, urban architecture and nature in the city. As this desire dug deeper roots, I took to the streets with my cameras, shooting both film and digital. I was fascinated by how the pulse of the natural world can feel similar to the pace of a city. Both are active. Progressive. Undeterred by setbacks. The tempo of big-city life is relentless, like strong vines that claw their way around windows, fences, and bricks. Urban living isn't usually designed to keep us linked to nature, but I was drawn to discover parallels between these two contrasting forces.

THERE WAS A GROWING SPARK INSIDE ME TO EXPLORE, IN TANDEM, URBAN ARCHITECTURE AND NATURE IN THE CITY.

My first city apartment was in Midtown East, a land of tall buildings and endless gray. On the weekends, I began to venture downtown to explore areas with smaller buildings, tree-lined streets, flower boxes, and community gardens—miniature oases of calm for city dwellers. My indoor plant story also started at this time with three little succulents—Jane, Bleecker, and Houston—all affectionately named after streets in Lower Manhattan.

I WAS FASCINATED BY HOW THE PULSE OF THE NATURAL WORLD CAN FEEL SIMILAR TO THE PACE OF A CITY. BOTH ARE ACTIVE. PROGRESSIVE. UNDETERRED BY SETBACKS.

A few years later, I traded living in the congestion of Midtown for Grove Street in the West Village, where nature was more present right outside my front door. During that time, my career branched off with unexpected, joyful new growth. I pivoted from being a full-time indoor office employee to working as a general manager at a boutique hotel in the Meatpacking District and overseeing a chic seasonal ice rink venue. During the winter, I loved leaving my apartment in the early morning and walking ten minutes north to the rink, simply being one with the trees in my neighborhood and enjoying the silence of sunrise. I put my passion for helping others into practice by coaching people of all ages in my childhood sport of figure skating.

The rink sat below the High Line, an elevated park built on the bones of old train tracks. The closeness of the park kept me

connected to the calm of the natural world as I encouraged my students' confidence to master new skills. Stepping on ice for the first time can feel scary, so I'd invite new students to pause, look up at the trees overhead, and breathe deeply in and out.

My involvement with sports coaching and my leadership role developing staff members reaffirmed that I valued helping people reach their goals. That awareness led me to a multiyear journey of learning. While balancing work and school, I built on my undergraduate degree in psychology to earn a Master of Science in applied industrial/organizational psychology from Sacred Heart University as well as a certificate in executive coaching from New York University.

From here, I began professional coaching for companies and

individuals with a focus on professional advancement, health, and personal relationships. To help my clients navigate situations to a place of understanding, discovery, and change, I integrated research-based tools and worksheets from my studies, and these resources were helpful. But in my gut I knew that something was still missing—something that could offer a greater transformational experience with lasting results.

The realization that the

missing piece was nature, and that it could be included in my work, came to me one day as my brother, Trevor, and I were out shooting photographs on the green streets of the West Village. The natural world had always been my source of energy and serenity. So I knew that a connection to nature could truly help my clients manage their stress and reach and sustain their goals.

Mindfulness was also key. Like the love of nature, it had been rooted long ago into my family background. I grew up with my mom teaching meditation to veterans and health-care patients, and I brought those principles into my own life and coaching business.

The seeds of psychology, coaching, mindfulness, nature, and a love of people grew together organically. That's when I began to intertwine my academic research with stress management techniques and innovative nature-centered practices in mindfulness, movement, and meditation. This evolution brought satisfaction to my life and work. No matter who you are, learning to create an intentional practice for noticing, connecting with, and being inspired by nature is a game changer. From the wide, blue-skied expanse of the West Coast to the congested concrete jungles of New York City, where I still live, I've had the honor of helping countless people develop a new way of looking at the world through a nature-focused lens, and I'm thrilled to share this practice with you.

Let's begin this journey together as we awaken to nature and invite it into our daily life.

OUR PATH TOGETHER

Awareness of nature's resilience can meet you in any moment, even in a grocery store parking lot where a concrete divider becomes a plant-filled space with a smattering of orange marigolds and Queen Anne's lace.

Once we resolve to truly *see* nature, we become awakened to a world of increased sensory experience. We may notice new growth on bushes that line a walkway, spot the ever-so-small signs that a new leaf is starting to form, or delight in how delicate flowers add color to an ice-cream shop seating area. All these moments with nature build upon each other, creating tiny connections like the tendrils of a vine climbing up, reaching out, and scaling a garden wall.

ONCE WE RESOLVE TO TRULY *SEE* NATURE, WE BECOME AWAKENED TO A WORLD OF INCREASED SENSORY EXPERIENCE.

A mindful connection with plants is free from judgment or expectation. There is just each plant, growing and blooming without constraint in its own space and time.

Mindfulness is freeing, and it bends our path toward positive connections and outcomes. It allows us to let down our guard, push back our defensive strategies, and let in only what is essential and unsullied, only that which exists and is experienced

through our senses in the moment. By sharing space with plants and reflecting on their paths to flourishing, we can become less critical of ourselves and others and more aware of our own gifts and opportunities.

When we share our lives with the growing world, every element, from the tiniest flower to a towering sequoia, reminds us that we are members of an ecosystem. If plants can change and grow from tiny seeds, we also have great potential for positive change and personal growth.

Though this journey will yield infinite results, there is only one precious moment of beginning. So let's enjoy this moment. Visualize yourself growing well with the help and guidance of the natural world.

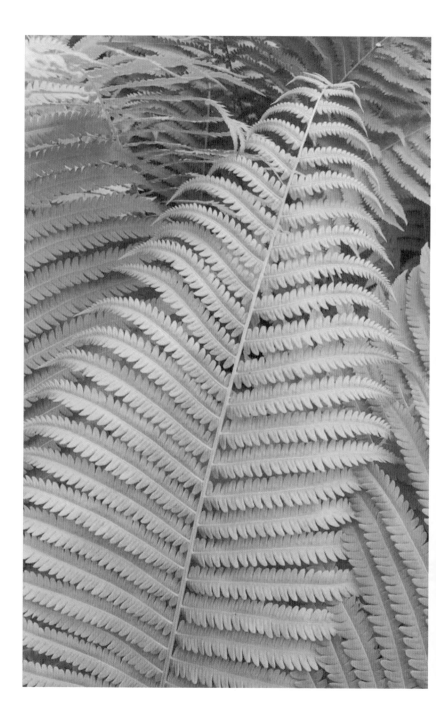

CONNECT

N ATURE REMINDS US THAT WE ARE WILD AT heart.

Though we may not always actively feel it, we humans have a deep-seated need to be in community with nature, to make an ancient connection new again. This is why we must return to nature, and connect mentally and physically to pockets or panoramas of wildness.

As we begin, bring to mind how a climbing ivy vine connects itself to a brick wall, stretching out its leaves and growing up toward the sunlight. Now imagine creating similar strong connections with everything green, from the parlor palm in a restaurant to a cluster of pine trees in a park. Together we will embrace a positive shift to awaken and strengthen our relationship with growing things. While we may often feel completely enmeshed in

our man-made surroundings, it's vital to our health and happiness that we pause to recall and renew our innate relationship with the natural world.

NATURE IS GOOD FOR US. IT CALMS AND HEALS.

We can do this by awakening our senses and creating mental and physical space in our busy lives to explore nature and return to the wild with elevated consciousness. Nature is good for us. It calms and heals. With increased awareness of our intimate connection, we may also find that we feel more inclined to take care of our wondrous world. Even when we're in a rush and our minds are preoccupied, the connection with nature is always available, waiting patiently to be rekindled.

For many of us, work can fill up a significant portion of our time and mental space. Whether in an office or doing manual labor, studying in a classroom or caregiving for those who depend on us, our work setting and responsibilities hold great influence over how we react and manage stressors, as well as how well we stay connected to what is important in our lives. Yet, no matter your situation, the nature-centered practices you'll learn in this section will become your ever-handy tools to stay mindfully connected to the natural world.

My own mindful connection to nature grew exponentially when I first moved to New York City and worked in the Chrysler Building. Walking into the iconic art-deco lobby each morning felt sacred and inspiring, but once off the elevator, I experienced a quick shift in energy. The expansive sixth-floor kingdom of cream

cubicles stretched the length of the entire street between Lexington and Third Avenue. Because it was positioned on a low floor in the canyon of tall Midtown buildings, the sunshine only dashed in and out of our windows as it crossed the city.

It was a land of high wall dividers and short, harshly lit ceilings. Each cubicle resembled the intensity of a grow light shining down on a baby plant in a fluorescent box. The workspace didn't radiate calm, nor did my sales assistant role of extensive data entry for million-dollar budgets. All day, I sat stationary, intensely staring at my computer screen, scanning spreadsheets line by line, making sure the money matched. Where I lucked out was having understanding bosses, the rare and nourishing duo of Donna and Sean, who valued their personal lives outside the office and never glanced twice when I left for my quick lunch breaks.

Every day at 12:30 p.m. I would push through the revolving doors in the lobby at Forty-Second Street near Lexington Avenue and start my search for greenery. In the Grand Central area of Manhattan, any bench placed next to plants filled up fast, so I walked east toward less crowded displays of nature.

Tudor City Greens quickly became my go-to lunchtime nature retreat. This small, refined park sits elevated above First Avenue, across the street from the United Nations. Far enough from the centralized hub of Midtown corporate life, the Greens required more effort and time to travel to and was speckled with only a few fellow office workers.

In those early days, I developed a routine of mindfully walking the gravel paths that traverse the green-filled space while focusing

on breathing slowly and evenly, in and out. I'd concentrate on releasing thoughts about work, and almost instantly, I'd start to feel a positive physiological shift back toward my calmer equilibrium. With practice, I was learning to better tame, control, and compartmentalize my stress.

I especially loved the park in spring because the well-planned blooming tulips, azaleas, and witch hazel were a stimulating contrast to the taupe and beige color palette of the office. The fresh aromas seemed to loosen any tightness in my body, and the colors still felt present as I returned to my desk, creating a lasting mental picture frame of vibrant florals around my computer screen that helped to better ground me while at my keyboard.

The Greens grew to be my restorative oasis for midday stress relief where I could reconnect with myself. And it was here in this two-block gathering of greenery, perched high above the city streets, that I was experiencing how I could quickly improve my response to incoming stressors. This win started to sprout new seeds in my mind, which would grow, mature, and continue to transform my personal and professional life in the decade that followed.

While my career took some different turns, nature remained my constant complement. When the opportunity arose, I began teaching my practice based on the foundation that nature creates a universal access point and common ground for people to experience calm and connection. It was clear to me that each person has a story that connects them to the natural world. A story that creates an impactful and relatable starting point and teaching tool.

Because of the Greens, I learned how mindful awareness and active presence are our special recipe to form a robust and renewing relationship with nature. It was the very beginning of the practice that I'll share with you in the pages ahead.

Together we will release unnecessary barriers and intentionally engage with our green and growing world. Our connection to the living world will become a calming resource, nurturing coach, and patient partner for practicing mindfulness, releasing stress, and growing well.

We'll begin by experiencing the exhilarating sensation of becoming completely awake to the natural world.

> Let's connect with this energizing, mindful moment,
> and breathe slowly and evenly in, then pause,
> and breathe slowly and evenly out.

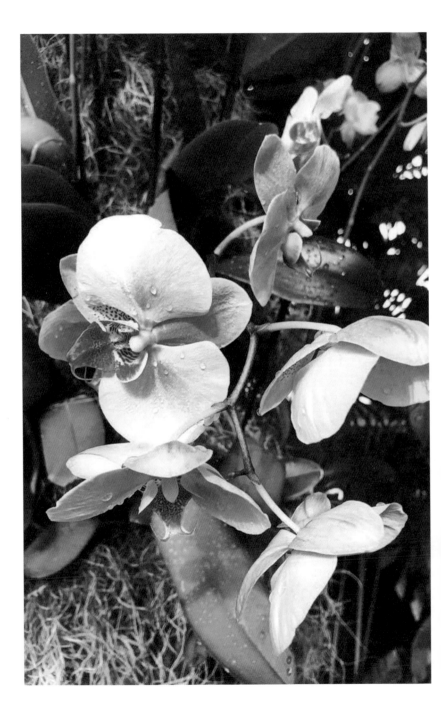

CHAPTER 1

AWAKEN

HOW AWAKE ARE YOU TO NATURE?

Pause to consider your personal relationship with the natural world. In your imagination, feel your senses awakened by the fragrance of fresh herbs, a damp forest floor, or sweet orchids. See the deep pink, yellow, and orange petals of zinnias in late summer. Hear the wind blow through the flat, heart-shaped leaves of a lofty poplar tree. Feel the prickly spines of a cactus or the velvety soft leaves of a purple African violet. Nature is a treat to our senses. Pure. Bold and subtle. Inspiring awe. Inviting intimacy.

To feel the power of sensory awareness, try to remember times in your life when you felt fully awake. Whether you were falling in love, or standing on the precipice of a challenging adventure, or letting yourself be enveloped by an epic musical crescendo, or celebrating a half-court buzzer beater, return to a moment you felt

your heart pound heavily in your chest. There was a jolt of vitality, electricity. Everything inside you came alive. Being awake means being mindfully present with your senses entirely switched on. As you begin to seek this kind of electrified sensory reaction in nature, you might find it easier to harness when looking out over a vast vista, such as the sun setting over a cattail bog. But with intention and practice, you can find the same sense of wonder in a single blade of grass.

It can be challenging for our minds to be truly engaged with our senses as we move automatically from one thought or activity to the next. A feeling of detachment can develop and continue undetected. Then suddenly, we realize we've been moving through our lives on autopilot. We can feel disconnected when our days are overly scheduled, either by accident or on purpose. We may be avoiding an issue we don't want to focus on, or just approaching life in a linear motion—never pausing, less present to our surroundings, others, and ourselves.

PATTERNS OF ANY KIND ARE EASY TO CONTINUE UNTIL SOMETHING MORE URGENT COMES ALONG TO BREAK THEM UP.

Patterns of any kind are easy to continue until something more urgent comes along to break them up. To exit this marathon and reawaken, we can pause wherever we are, check in with ourselves, and return to our breath and the present moment.

To be completely awake and engaged in the present, we need to let go of any concerns about the past or

future. When distractions and disruptive thoughts go quiet, we are better able to connect with incoming sensory experiences. It's in this place that nature can become our catalyst, our change agent for calmness and growth.

When we really *see* greenery around us, hope is present and possible. Nature can encourage a surge of energy and a feeling of contemplative stillness in every moment. Being awake to the natural world and its magnificent displays, grand or unassuming, unleashes our capacity to grow new layers of awareness in our own lives, deepening our thoughts and feelings.

We experience a ripple effect when we truly embrace the world around us, absorbing nature with its various colors, textures, and scents, awakening us to heightened sensory experiences. Not only do we become more present to nature, we also become more present to everything and everyone around us.

Before we begin our first affirmations, meditations, and how-tos, I'll pause to replant the idea that each of the following exercises was created to support your well-being and connect you to different forms of nature. All these tools will help mold your best practice. Take time to adjust your posture by sitting or standing up tall, then take slow, mindful breaths. Be encouraging of your progress and welcoming of emotions that may be unfamiliar or challenging. Finally, remember to stay present to the nurturing nature that grows with you on this journey.

With gratitude for the natural world, join me as we wake up our senses.

I AM AWAKE

I am awake to my senses.
I am awake to my needs and desires.
I am awake to my connection
with the natural world.

MY NATURAL SELF

I awaken my natural self
and connect to my roots.
I stand out, never blend in.
I shine a different light
and celebrate who I am.

SEEING BEAUTY

No matter where I am or what occurs,
I commit to seeing beauty in greenery
and in myself.

Blooming Grounds

Breathe slowly in, pause, and breathe slowly out.
Imagine walking through blooming grounds.
A stone labyrinth weaves its way through the
blossoms and greenery. It is good to be here.

Lush, dark green vegetation brings you joy.
A brightly colored flower has fallen on the path,
and it invites you to take a closer look. Step toward it.
As you do, breathe slowly in, and slowly and evenly out.

Pick up the flower and gently touch its soft petals.
How do they feel between your fingers?
In this moment, you are aware of the
fragile yet resilient essence of life.

Continue to breathe slowly in and slowly out.
Walk through this scene in your imagination.
Feel the spongy yellow-green moss beneath
your feet and listen to the vibrant symphony
of sparrows singing in a chorus round.

A gust of wind rushes through the greenery
and silences their song. A few bees harvest nectar

on soft pink dahlias, then hastily buzz by. More bees come to
dance with the flowers, back and forth, mimicking a mating ritual.
Then they move on.

Finally, it's your turn to smell the flowers.
Walk carefully toward the dahlias. Before you bend down,
breathe and allow your whole body to be present in this moment.
Nature is incredibly busy. You admire this quick, calm circus.

Lean in and fill your senses with the rich colors and
scent of citrus. Nature's mastery of aromas amazes you.
Breathe in and savor the moment.
You can almost taste the ambient sweetness.
Store these sensations.

Stay here and secure the memory.
You can return here anytime in your imagination.
When you are ready, continue on, mindful of the
many ways nature wakes up and colors your world.

Body Scan

Breathe peacefully in and out. Feel centered and assured.
Visualize a small plant recently propagated in water.
Appreciate how its new root system
supports its present and future.

Follow an imaginary path from its roots
to the stems, carrying necessary nutrients to new leaves.
Scan the young plant to see the small parts that create the whole.
Details matter in nature and in our lives.

Now focus on yourself. Scan your body.
Notice any sensations in your feet and legs.
Become aware of any tension in them,
and release those feelings with a
deep, cleansing breath.

Consider the position of your arms and hands.
Are they relaxed or tense? They work hard for you.
Let them be still now and breathe in relaxation.
Allow a wave of calm to flow down your arms
and out your fingers.

Now shift your attention to your face and head.
Notice any tension in your forehead, around your eyes or mouth.
Does your head feel light or heavy? Let it be relaxed and still.
And with your breath, create a pathway to peace.

Breathe peacefully in and out. Feel centered and assured.
Remember, you can practice this plant-based body scan
anytime you need a moment to awaken your mind
and body and feel connected to nature.

Droplets

Picture a plant after a rain shower,
and notice how the leaves hold onto water droplets.
A multitude of shimmering molecules form circles
supported by the strength of a hardy plant.

Zoom in and awaken your eyes to the random pattern of drops.
Breathe in deeply, pause, and then slowly exhale. Awaken your
mind to the beauty of natural elements coming together
and to the ways beauty combines in you.

Consider the unique qualities of your physicality.
Begin by focusing on your facial features. Then your hair and skin.
Awaken to the beautiful parts of your personality and beliefs,
noticing the many different elements that collided to create you.

Like water balanced on plant leaves,
your body and mind bring all of who you are into balance.
Awaken to nature's beauty and to your own. Then take another
slow and even breath in, pause, and let it out slowly and evenly.

AWAKEN TO THE SMALL THINGS

Let's practice being fully awake by connecting with small elements of nature. To begin, go outside. You don't need to have access to a meadow or a forest; it can be a city sidewalk or a public park.

- To start, breathe in, pause, and breathe out slowly and evenly. Be mindful of your breath as you prepare to wake up to smaller parts of the natural world.

- Standing outside, allow your eyes to notice the facets of nature that you can interact with today. What tiny parts of the natural world are in this setting? Look around. What do you see? Maybe your attention is drawn to a piece of clover or a new leaf. Select one item and get yourself up close to it.

- Study this small part of nature with childlike wonder. Simply experience its shape, color, and texture.

- Now, without evaluation or judgment, begin to call out in your mind the shape, color, and texture of what you are experiencing.

This exercise of sensory wakefulness is a reusable tool to strengthen and refresh your connection to all living things.

CHAPTER 2

CREATE SPACE

WHEN YOU FIRST THINK ABOUT CREATING space, what comes to mind? Perhaps you would like to create more space in your closet to make getting dressed in the morning less chaotic and stressful, or maybe you'd like to create more space on your desk to foster better productivity. Moving beyond the physical, maybe you'd like more emotional space in a relationship, or mental space to nourish your imagination and creativity. Creating space is meant to separate, to establish distance between one thing and another. By creating a sense of mental and physical separation from what takes up your time and energy, you can welcome nature in.

Creating space to connect with nature can be done by sitting on the grass instead of a bench. Breaking the pattern of our normal routine and completely absorbing the calm of the natural

world opens us to inner growth. Intentionally creating space for nature allows our connection to deepen. Being truly present to the gorgeous leaves of a *Philodendron gloriosum* can help release inconsequential thoughts and create a sense of meaningful connection.

NATURE CAN TEACH US THE VALUE OF CREATING SPACE.

Nature can teach us the value of creating space. We can move a houseplant from its nursery pot to a larger pot to help it grow and flourish. By selecting a pot that is a little bigger than the previous one, the plant is given room to roam. I use two fingers to measure the distance between the roots and edges of the pot. This distance creates space for the plant to grow in both its roots and leaves. Like plants, people need space to live and grow well. I like to think of my end-of-day walks as that two-finger distance in the pots—just enough room to let me breathe anew.

Bring to mind the usual pattern of your day. Consider ways you can create mental and physical distance from the demands of your routine, and fill that space with experiences in nature. Perhaps you can take a midday nature-centered walk or stop by a park after dinner. Pick up some flowers from the market for your kitchen table. Look up to see the color and silhouette of treetops against the sky, or enjoy signs of the changing seasons. Open your windows and listen for the call of birds or the gentle pitter-patter of raindrops. Plant flowers or grow fresh herbs. You can even experience the produce section of a grocery store with your senses

switched on. Practicing mindful awareness of nature in all forms can help us create space to fully connect with our flora-filled earth.

When the routines—or the chaos—of our regular days are not grounded by habits that connect us to the natural world, it's no surprise that we can begin to feel unsteady and insecure. Even taking that first step to create mental space can be challenging. Yet with nature's help, we can boost our confidence to reach out beyond our current thoughts and experiences, past what feels comfortable.

To nurture this assured mindset, we can learn to create space through each of the following affirmations, meditations, and how-tos.

RELEASE BARRIERS

With intention, I release barriers.
I create space and expand my thoughts.
I extend the stems of my imagination.
I feel the roots of my potential stretch out
past what previously felt possible.

I DANCE

I dance in a direction that allows me to grow.
I pirouette past what is known and understood.
Like a new leaf, I reach out, stretching farther.
I pivot, if needed. And with each step,
I create space to sow new growth.

WANDERLUST

I create the space needed to expand.
I connect with my natural self and grow well.
I am eager, not fearful. Curious and calm,
with a wanderlust for the unexpected
and a welcoming embrace of happenstance.

Outside World

Breathe slowly and evenly in and out.
Bring to mind a busy day at work or tending to tasks at home.
Feel the pressure of the many opportunities
and challenges that can arise during those hours.
Now allow yourself to step away.
The responsibilities will be there when you get back.

Imagine getting up and opening a door to the outside world.
A moment of refreshing air is exactly what you need.
Take a deep breath in, and let it go slowly out.

Leave behind any unwanted thoughts or feelings.
See a natural setting before you, such as a small garden or park.

Walk into it. Bring nothing with you but this moment.
Allow calming shades of green to fill your vision and
restore your spirit. Capture this moment in your mind,
and keep it in your memory.

Take another slow and even breath in, and then let it out
slowly and evenly. When you are ready, come back
to where you are, knowing you have the resources
and the will to create space.

With Every Scoop

Take a cleansing breath in, pause, and let it out slowly.
Bring to mind an outdoor patch of soil, rich in nutrients
and ready to help plants grow.
Imagine picking up a trowel.
You start to disturb the even layer of soil,
rhythmically digging space for a new plant.

Focusing on the relaxing repetition of this action
brings you calm. Stay in the present moment.
With every scoop of dirt gently placed to the side,
you create space for new life.

Observe the hollowed-out area in the earth, and consider
how each positive step can make way for what comes next.
With care, lift the plant into your hand. As dirt releases
from its roots, notice how well-developed they are;
their hardiness will give this plant its strength.

Imagine for a moment that you are the roots.
You feel the industrious nature of this intricate system.
You are strong and determined to succeed.

Now imagine your own life, anchored in the earth,
mindful of nature. Feel empowered to create space
and enjoy this moment. Breathe in and breathe out.

In the Void

Breathe in with intention, fully and deeply.
Breathe out, releasing the borrowed air
back into the natural world.

Allow anything that consumes your thoughts to fall free
from your consciousness. Unpack unwanted feelings.
Empty them from your mind. Let go of stressful thoughts,
and connect with the image of a growing plant.

Notice how leaves stretch and separate to make
room for new growth, the promise of tomorrow.
This new space gives foliage the opportunity
to reveal its presence, begin its voyage,
and claim its place.

Imagine how a new leaf appears in the void,
nourished by its roots, reaching its face to the sun.
Attached to the whole, but on an independent journey.
Through a clearing in the crowd, space is gifted for it to grow.
Stay connected to this new leaf, making its way.

Stay connected to the potential of space and growth.
Imagine how creating personal space can allow you
to expand your perspective and continue to grow.
Breathe in, pause, and breathe out.

Sharing Space

Breathe calmly in and create space in your lungs for clean air.
Breathe calmly out and create space in your mind for nature.
Continue this breathing pattern, and with every breath,
visualize where you live and your surroundings.

Take time to notice the details and decorations around you.
Imagine new ways to share your living space with plants.
Breathe evenly in, pause, and breathe evenly out.

Feel the energy of opportunity to create space for nature.
If you already live with plants, be mindful of what you moved
or added to make physical space for them to grow and live well.

Stay present with your focus on where you live.
Notice where windows may let in sunlight.
Does the light shift and move during the day?
Does the sun shine brightly or softly?

Take another slow, even breath in, then pause,
and let it out slowly and evenly.

Think about what kind of plant you would like to bring
into your home. And feel confident in your ability
to create space to connect with nature.

CREATE SPACE

Take yourself to an outdoor area that is wide open. Or, if your current setting allows you to view nature at a distance, you can stay where you are.

- Begin by taking in a renewing breath. Feel your lungs expand. Pause, and let the air go out slowly. Stay aware of how you can create space in your body and mind.

- Stand still in your setting, and look out to the point farthest away. What are some of the natural elements you can see? Focus on one thing—perhaps a tree or a hilltop—and then move your attention to another point in the distance.

- Now listen for distant sounds. Take another breath in and feel calm, knowing you can create physical and mental space.

- Stay centered on this distant gaze, then mentally teleport yourself to the farthest point. Challenge your mind to stay in that faraway place, then imagine looking back on yourself in your current physical location.

- Continue to focus on your breath. Repeating this pattern of being present to where you are physically and then mindfully being in a distant setting can broaden your perspective. Return to this exercise whenever you feel the need to create mental space and expand your point of view.

CHAPTER 3

EXPLORE

M OMENT BY MOMENT, PLANT BY PLANT, IF WE look to find an intentional connection with the wilder world, nature will generously share its many gifts with us.

To fully explore New York City, I needed to notice nature and admire the fascinating placement of plants among the stone, cement, brick, metal, and glass—some of them were placed and cared for by the intentional hand of man, while others grew wild at nature's discretion.

Now when I'm out exploring, the mash-up of well-tended courtyards and random weeds mellows my mind and reawakens my senses. A mess of urban gray dominates; then, out of nowhere, plant life appears with a plan to grow tall and strong. It disturbs and emboldens the man-made landscape of steel and concrete with the natural life that was here long before buildings darkened the sun's reach with their shadows.

I'm amazed and inspired by plants that give life a solid go, even in the most unfavorable conditions. What we may call "weeds" are nature's true champions. Imagine possessing the boldness of a dandelion as it breaks through a crack in the sidewalk. It grows with purpose to show off its spiky green leaves and sun-yellow face.

WHAT WE MAY CALL "WEEDS" ARE NATURE'S TRUE CHAMPIONS.

Next time you are walking on a street, in a store parking lot, or in another commercialized area, dedicate your attention to the small slivers of life that may be growing at your feet. If you look to see the wildflowers brave enough to grow on a highway median, you'll grow to respect those weeds as much as you admire a stunning magnolia tree in bloom.

At the edge of Manhattan's West Village, the entrance to the High Line at Gansevoort Street and Washington Street is my personal magnetic north. My maternal great-grandmother spent her early childhood in a building that once stood on this corner. During my third year living in the city, I moved into an apartment nearby and would run through the park before sunset, crossing the same cobblestones where she may have stepped more than a century before I was born. An unlikely intersection of past and present connected both of us to the earth below.

On those runs I continued to develop my intentional act of noticing nature and creating moments for wonder, especially in urban landscapes. This desire gets me out and moving, restores my

natural rhythms, encourages positivity, and keeps me mindfully connected to the earth under the asphalt.

Whether we notice the character of a neighborhood reflected in a community garden or bare tree branches against a blue sky, when we pause—in our minds, if not in our steps—we open up to nature. Our connection to greenery feels complete when we take time to explore and recognize our kinship with all living things.

Actively exploring nature benefits all aspects of our health and exercises our ability to live in the present moment. Join me for the following affirmations, meditations, and how-tos as we explore nature in urban environments or anywhere you may be.

GREEN AND GROWING

I will notice where urban meets nature.
I will respect nature's presence and purpose.
Even in the scramble of a busy day,
I will explore what is green and growing.

I SHOW UP

I show up for myself.
I show up to see the world around me.
I show up to explore my connection to nature.

INNER EXPLORER

I am naturally curious
and activate my inner explorer
to discover nature's wonders.

Urban Wild

Breathe slowly in and let your breath go slowly out.
Let's go for a walk on the High Line.

In Lower Manhattan near the Hudson River,
a historic railway line has been preserved,
transformed into a well-traveled green space
that pulls nature farther into the sky.
Begin to climb up the wide steel stairs
until you reach the elevated, thriving park.

Within this space, your connection with nature wins out.
The multitude of buildings, cars, and people drop back.
Your eyes follow the railroad tracks among the plant beds.
Vines cascade off the elevated pathway toward the busy
street below. Black-and-white birch trees
stand out against the greenery.

Well-worn nails and numbered rails remain visible.
The decades-old wooden ties connect you to those who laid them.
Heavy spikes pounded into the ground are still seen.
Strong and sturdy, the railway serves as witness
to an ever-changing city.

High above the rails, the spire of the Empire State Building
shines in the sunlight, surrounded by a cacophony of buildings
of all shapes and sizes. You see it through a frame of greenery
growing wild in the park. This urban jungle brings you joy,
energy, and a sense of calm.

As you walk, untamed plants line your path.
The armament of nature gently wraps around the wood and steel.
You are at once mindful of the past and, at the same time, present
to yourself. Connected to the city and the natural world.

The High Line is filled with wild grasses and perennials,
changing textures and colors, colliding to create a space
apart from the city below, yet effortlessly contributing to its beauty.
You feel grateful for this experience.

Here you are free to explore the random, intentional,
and wonderful ways urban development meets the natural world.
See the texture of weathered planks against pale-green leaves.
Wildflowers wave gently with the wind off the river.

The scent of the city is replaced with an unexpected freshness that
drifts up from being close to nature. Give yourself time to be one
with these different but connected worlds.
When you are ready, go on with your day,
mindful of the many benefits of nature in the city.

Nature and the City

In this moment, be open to your imagination.
See yourself walking on a crowded city street.
Locals and tourists mix to paint a bustling city scene.
Your eyes and ears are captivated by this
sensory-soaked environment.

Take a deep breath in, pause, and release it.
Begin to connect differently with the scene around you.
Rather than seeing the ever-present sharp angles of the city,
look for notes of nature.

Notice tree roots pushing up a slate sidewalk, yellow flowers
blooming in a window box on a stone ledge.

Enjoy this moment. Take time to greet and connect with nature.
As the hectic pace of the city fades into the background,
the natural world welcomes you to its urban home.
A tangled union of textures, living and still.

You approach an open gate that leads down an alleyway.
A sign reads "Welcome to Our Garden." You venture in.
Someone has created a space for others to explore city nature.
The path you're on leads behind the brownstones to a courtyard.
Fire escapes crawl up the buildings on either side.

You sense an immediate connection with the beguiling greenery.
The quiet of cultivated nature welcomes you.
You are invited to explore this plant-filled plot of green.
The soft mulch on the path feels refreshing under your tired feet.

Breathe and walk through the nature that surrounds you.
Feel the calm of flowering bushes and colorful begonias.
Now look up to a single tree in the middle of the courtyard.
Tilt your head all the way back and look toward the sky.
Explore how the tree spreads its branches high into the air.

Slowly bring your gaze back to eye level, and see how
trailing vines decorate a fence that divides
one backyard from the next.

Notice the vines weaving together,
creating a garland of greenery above the fencing.
From where you are, the vines travel on into the next courtyard,
Connecting city neighbors with the gift of this garden.

Breathe slowly in and out. Feel fortunate to explore this space.
Stay in the courtyard for a while. When you are ready, continue on
with mindful awareness of the many ways that nature in the city
is present for you to explore and enjoy.

Grove Street

Bring attention to your breath. It gives you energy to move.
Now imagine walking swiftly down a city street.
Swing your arms and extend your legs in a forward stride.
You can keep up with the speed of the city.
Turning the corner, something catches your eye.
You look up to a display of city greenery.

Before you stands a stunning townhouse
made even more appealing by the vines
that create a natural art installation on the brick.

Unplanned, you pause to explore the sturdy stems.
Its network of leaves covers the prewar home
and effortlessly reclaims nature's place in this space.
You appreciate the owner allowing greenery to grow uncontrolled.

Follow the lines of the vines
from the ground to the rooftop and
take in what is larger than yourself.

In the city, nature is the artist in residence,
free to express her wild side and
free to bring joy to those who see her.

This house would still be beautiful without the twists and turns
of these hardy vines, but you can't imagine that now.
Their beauty cannot be replicated or replaced.
Breathe slowly in and slowly and evenly out.

The Ramble

Calmness envelops you when you explore the natural world.
Breathe in slowly and evenly, then breathe out slowly and evenly.
Begin to center yourself on the rejuvenating essence of a park.

Imagine you are visiting the Ramble in Central Park,
a densely wooded area that appears wildly untouched,
a sanctum for flora and fauna that washes over your senses
and invites you to connect with nature and explore.

Without a set plan of what to see or experience,
you join other visitors on a nearby path lined with
wooden railings that define the walking space
through mature trees and expansive, untrimmed brush.

Breathe in, pause, and breathe out. Feel enmeshed
in the web of nature trails and uncultured vegetation.
Watch flowing water as it somersaults down a narrow stream
and splashes against boulders, creating a natural percussion section.

As you walk on, you come upon a vintage stone archway
that shields you from the sunlight. Entering the arch,
you take a mindful pause to appreciate this darker moment
in the light of a day in nature.
You travel through it and reemerge into the sunshine.

The path you are on appears to be a thoroughfare
for woodland animals. Chipmunks dart back and forth.
Birds engage in aerial acrobatics, and squirrels chase each other in
circles on the grass then scurry up a nearby tree and run across a
tightrope of branches near the top.

The surprise of finding this expansive natural scene
just five minutes from a cityscape under human control
is energizing and hopeful. Here in the Ramble,
you strengthen your desire to connect and explore nature.

Continue to breathe and stay present to the park. Remember,
you can return to this moment in your memory anytime you want
to reconnect and explore the wonders of wild greenery.

EXPLORE

Let's practice exploring nature by being present in the moment and taking an intentional, 360-degree view of the natural world.

- Go outside and find a safe and comfortable location to stand or sit. From where you are, breathe mindfully in and out. Focus on your breath as you connect to this moment and the act of exploring.

- Begin a 360-degree exploration of your surroundings. Like an adventurer starting out on a voyage, start by looking straight ahead. What do you see? Without moving your feet or chair, look left, then right. Take in all the views you can observe. Look down to the ground and then up to the trees and the sky.

- Make a quarter turn right and focus again. Look left, then right, then down, then up. Explore with your eyes what nature surrounds you. Take another quarter turn right, and focus left, then right, then down, then up.

- Continue turning until you're back where you started. Take another breath in, recentering on the present moment, then breathe out slowly and evenly. Before you move on, recall the different natural elements you observed during this time of mindfully exploring a 360-degree view of nature.

EXPLORE MORE

Let's practice exploring nature. This exercise takes you on a nature-centered quest to activate your inner explorer and innate ability to connect to the living world. You're welcome to go exploring alone as a fun self-care practice, or invite others to join you. Plan to incorporate all or part of this exercise into your week as an actionable path to sustained mindful awareness of nature.

Find five items in one category below, or check off all five items in multiple categories. Consider bringing home from this quest an available piece of nature. A pine cone, acorn, rock, or stick placed on your desk or shelf display can keep your mind connected to the inherent desire for exploration. Or choose a fallen leaf or flower and press it between the pages of a book to preserve for future reflection. If you live near a seashore, perhaps you'll find a shell or polished beach glass.

- five different trees
- five different plants
- five different colors
- five different flowers
- five different shapes
- five different textures
- five different nature elements in a park

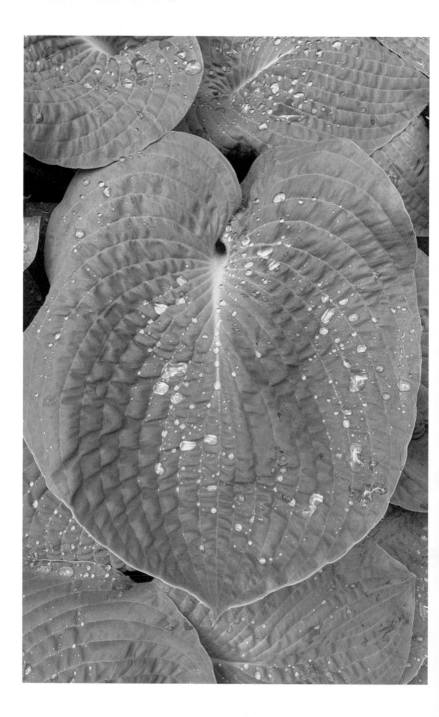

CHAPTER 4

RETURN TO
THE WILD

THE LANDSCAPE WHERE WE LIVE WAS ONCE wild in all directions. Wilderness thrived everywhere in solidarity. Growing unkempt, reproducing, adapting, and evolving without human interference.

If we went far enough back in time, there would be no need to seek out the wild. Wherever we looked and whatever we heard, smelled, tasted, or touched would be a product of the natural world, untethered to the influence of humankind. Before there were early settlements, farms, roads, bridges, cities, and skyscrapers, there was just the wonder of nature.

Today, most of us need to make returning to the wild an intentional act. We must forgo the indoors and seek out the wild to deepen our connection to greenery. Wrapped in our wish to connect to nature is our aspiration to exist unmanaged. When we

connect with the vivacity of nature, our spirit sprouts with healthy energy and a desire to test our self-imposed boundaries.

There is a kind of power transferred from the wild to those who enter its presence with respect and kindness. When we connect with the wild, strengthening our relationship with perennial plants, majestic trees, and mossy waterfalls, we also absorb its power and endurance. Just as we fuel our bodies with food, our need to nourish this nature connection is instinctual and vital.

Our souls might be longing for the deep green of a forest or the tangled vines of a tropical jungle, but we can find glimpses of these wild landscapes in our everyday world. Perhaps we might plan a trip to a local park or nature preserve, hiking trail or river walk, seashore or national park. Even as we dream about these natural getaways, it's important to acknowledge that life doesn't often permit us to return to nature's physical presence in the precise moment we desire to, and that's okay. We can still act upon this need by pausing to connect with the wild in our minds. Being mindful of nature is a rewarding act of consciousness. We can return to our favorite natural settings anytime through our memory and imagination.

BEING MINDFUL OF NATURE IS A REWARDING ACT OF CONSCIOUSNESS.

When I stop, breathe, and reflect on nature, I can imagine I'm in the dense rainforest of Nicaragua, looking up at Half Dome in Yosemite Valley, or walking among the tall redwoods of Northern California. Practicing imaginative contemplation increases my

capacity to recall the wild when I am back home, separated from its wonders.

It is my hope that as we grow our connection to the wild and feel one with nature, we will also increase our care and protection of the planet. To reap the benefits of all that the wild offers us, we must ensure its survival. It is a sacred trust—the give and take between people and planet—and it's vital for our own existence. Returning to nature can motivate us to safe-guard public lands, create more protected areas, and secure the health of ecosystems. We must return to the wild to continue to be students of the ultimate teacher. When we observe, learn about, and meditate on nature's variety, we can better appreciate diversity among all living things, including people.

Together, let's experience the following affirmations, medita-tions, and how-tos, each designed to naturally support our return to the wild. Nature is calling us, and we know the way.

UNTAMED

I am untamed, strong and prevailing.
The wild in nature sets soaring
the wild inside of me.

TRACKLESS

I feel alive in the trackless wild
of the wilderness.

THANK YOU, NATURE

Thank you, nature, for keeping your course.
And moving me to hold true to mine.
I appreciate your strength and tenderness.
I respect your determination.
I follow your lead to be humble
yet unapologetic in achievement.

Searching

Breathing in, you are fully living in the present moment.
Breathing out, you are happy to be in a quiet, peaceful place.

Breathing in, you resist controlling your breath.
Breathing out, allow your breath to flow naturally out of your body.

Breathing in, you search for nature in your imagination.
Breathing out, you find a kaleidoscope of greenery.

Breathing in, you search in your mind for nature by design.
Breathing out, you discover a garden and park.

Breathing in, you search for forests.
Breathing out, you find a family of ferns.

Breathing in, you search for deserts.
Breathing out, you discover an abundant variety of cacti.

Breathing in, you search for tropical flora.
Breathing out, you find a thriving bird-of-paradise.

Breathing in, you search for nature's patterns in a backyard.
Breathing out, you find the intricate designs in tree bark.

Breathing in, you search for small signs of new life.
Breathing out, you discover the beginnings of a budding leaf.

Breathing in, you are grateful for the plants in our world.
Breathing out, you are aware of the protection they need.

Breathing in, you observe the continuum of nature in each moment.
Breathing out, you feel connected to the earth
and responsible for its care.

Awaiting Wildness

Imagine yourself standing at the foot of a nature trail.
The path quickly turns to the right. You know little
of what wilderness awaits you.

Breathe slowly in and out.
Feel humbled by the opportunity to return to nature's
home and eager to interact with the living world.

Take a few steps on the trail.
Greenery crowds in on both sides. Palm trees are abundant.

Low branches reach down to meet the tallest leaves of plants
stretching up from the ground. The vegetation is almost foreboding.
You realize returning to the wild requires you to trust the living
world. You embrace its abundance and mystery.

Pause. Breathe in and out. Stand still, and look ahead into the wild.
Widespread leaves crisscross and lie gently on top of each other.
Plants and trees form green intersections.

Follow the lines of stems and tree trunks.
Watch how the scene, once complex
and cluttered, begins to simplify.

Continue to engage with the feeling of returning to the wild.
Breathe in, pause, and breathe out.
When you are ready, return to where you are.

Road Trip

Breathe slowly in and slowly out. Imagine you are on a road trip to
discover nature with someone you love.
This adventure takes you to a narrow road,
touched on both sides by sand. It divides the expansive desert
before you and provides a path to follow. The day consists of
bright sun and dry heat, cloudless sky and endless horizon.
Completely surrounded by this breathtaking land, you are at rest.

The stressors of regular life are removed by the desert.
Feel the freedom of this experience, and smile.
You're in a place where plants stand witness to the passage of time.

Stepping out of the car, your feet are greeted by forgiving sand.
You walk toward the saguaros, a century in the making,
standing tall and sturdy against the desert sky. Other visitors
have traveled far to take in this impressive natural display.
You feel linked to those who desire this connection.

Standing next to a towering saguaro, you feel a rush of wonder.
Resist feeling intimidated by its striking size and permanence.
Instead, with great respect, you pull inspiration from its strength.

You will remember this moment when returning home.
The cactus will still exist, and you will be bound to it
in your reflection.

Take another slow, even breath in, then pause and
release it slowly. When you are ready,
continue on your way, connected to nature no longer in view
but present through conscious connection.

Playa Maderas

Breathe slowly in and out, and allow the anticipation of connection
to saturate your mind and body. Today you will return to the wild,
relinquish control, and embrace a world unfettered by humans.
Feel power in your ability to let go, loosen your grip,
and unite with the wild.

Imagine yourself waking up in a small cottage surrounded
by miles of tropical terrain. The road to get here is unmarked;
only locals who grew up navigating this place can bring you here.

Your phone searches for service that it will never find.
You turn it off. In order to connect to this space,
you must disconnect from what is routine and known.

Take a cleansing breath in, pause, and breathe slowly out.
Visualize leaving the cottage to begin walking barefoot
on a dirt path lined with thin, gangly trees that extend
up to a cloudless, azure-blue sky.
A monkey calls out above you, then lassos its tail
around a tree to reach out for a distant branch.
You're reminded of whose home you are visiting.

Under your feet, you start to feel a coarse, sandy ground,
one that is different from the dirt. Near the end of the path,
sparkling seawater catches your eye.
You smile and walk faster.

Before you sits a vacant cove. You feel completely alone,
but in the most wonderful way. This morning moment is all yours.
Feel eager and grateful for the opportunity to reunite
with the natural world. It is low tide, and to your left,
a small opening of sand appears between the rocks
in the water and the cliff that meets the sea.

Walk toward the slice of sand and begin to experience this new, wild setting before the tide returns. Notice how the sand changes from semi-coarse to soft between your toes.

See a gathering of jagged rocks in the water appearing as sculptures decorating the seascape. Notice how the strip of sand widens, and imagine trees and vegetation sprouting up at the base of the cliff.

Continue to visualize exploring this wild nature by the water. Think about how distant you feel from the life that people create. Bring your attention back to your breath and acknowledge the magnitude of nature. Mindfully keep this wild scene with you as you come back to where you are.

RETURN TO THE WILD

Let's practice returning to the wild with the help of videos, drawings, photos, and intentional thought to increase your ability to connect to the natural world wherever you are. For this exercise, you'll need to collect a few visuals to help facilitate your virtual wild experience.

- Video: Watch a nature documentary or travel show. As you begin, allow yourself time to take in the natural scenes and get a feeling for what it might be like to truly be there. What might the air feel like? Is it humid or dry? What smells might you notice? How might you feel? Now pause the video and close your eyes. Imagine yourself in the scene, and re-create the setting in your mind. Continue this pattern of watching, pausing, and visualizing being in this wild place.

- Drawing: Get a piece of paper and a pencil, pen, or marker. Now imagine a wild setting that you have visited, and begin to sketch this scene from memory. Don't focus on perfection; simply recall what you remember. Stretch your mind to see the details, and try to reflect it on the page.

- Photo: Hold a physical photo of a scene that you captured or one stored on your phone. Focus on all the natural elements in the photo. Go from corner to corner, top to bottom, recalling what it is like to be there. Stay in this moment, and enjoy once again that time and space in the wild world.

NOURISH

PEOPLE AND PLANTS. OUR DIFFERENCES ARE abundant, but in the simplicities of life and our need for nourishment, similarities rest at our cores. As parts of the living world, we grow on kindred paths. Sometimes people help plants to receive the nourishment they need; other times, plants nourish people by supporting our health, improving our mindset and well-being, expanding our thoughts, and opening up new perspectives. Our interconnectivity with nature offers the nourishment to welcome in renewing light, joy, compassion, and self-love.

Plants play a pivotal role in nourishing our bodies to maintain a healthy quality of life. We grow and consume plants for taste and nutrition. They provide vitamins, minerals, protein, fiber, and carbohydrates and are used for coffee, tea, sugar, oil, and spices. From the roots and leaves to stalks, flowers, and fruits, plants sustain us.

When I experience a lack of proper nourishment, possibly from being caught up in the speed of contemporary life, I notice how this unintentional neglect affects my mind and body, leaving me depleted. I can also feel drained of energy when I'm not engaged in nurturing activities like being outside, taking photographs, socializing with people who inspire me, visiting those who rely on my help, or going to invigorating live experiences like concerts or sporting events.

Think of a time when your mental bandwidth, energy, or physical capacity experienced prolonged strain. These experiences present an exposure point to confront the negative effects of insufficient nourishment and an opportunity to choose new, nourishing actions going forward.

We can recover like a plant that has endured a severe drought. When the rain does come, pouring out a needed soaking, the plant can begin to come back to life. The stems straighten and the leaves unfold. Yet to sustain strength and good condition, the plant will need continued periods of rainfall. And even when the plant regains its nourishment, it must focus on growth to increase its resilience for future shortages.

THE NATURAL WORLD REENERGIZES ALL WHO PAUSE TO CONNECT AND GROW WITH IT.

The natural world reenergizes all who pause to connect and grow with it. It helps us create a calm foundation for a healthier, happier life. It takes time and practice before these good intentions truly set in and gain roots. To develop

well, we need to nourish a mental marriage of diligence and patience that can be strengthened by exposure to nature.

Nature gives us a free master class on daily ways to nourish paths of prosperity. Steady and proactive effort is necessary for us to bloom. Invite this broadened awareness to stay with you, and expand your interpretation of where, how, and what kind of nourishment you can receive from nature.

> Let's embrace this nourishing, mindful moment
> and breathe slowly and evenly in, pause,
> and breathe slowly and evenly out.

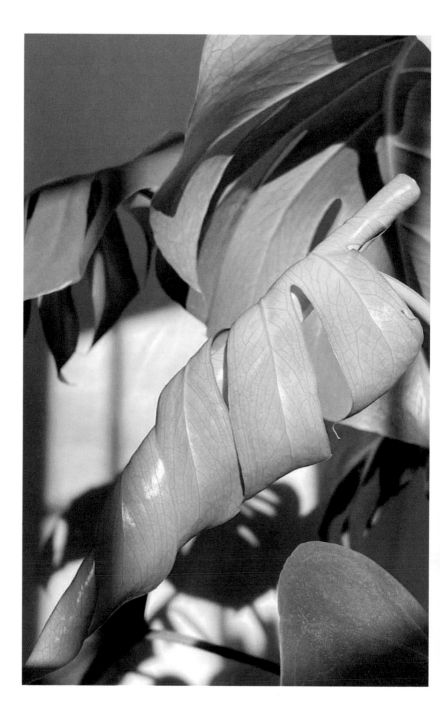

LIGHT

WHETHER IN THE ACTUAL OUTDOORS OR JUST in your imagination, call to mind the pleasant feeling of sunlight on your skin. Fully absorb your whole being into this moment of receiving the sun's energy. Let the light brighten your mind and mood. Enjoy your awareness of its presence. The sun's full light may be slightly garish but grand.

Now consider how sunshine sends nourishing warmth through your body and how it shines on plants, giving them the vitality they need to radiate a rich, glorious green. For plants, sunlight is essential to the process of photosynthesis, where light energy is converted into chemical energy, producing sugar molecules. These mighty molecules are available to the plant to use or store for later.

Noticing light and the many ways it interacts with nature has become one of my fondest hobbies. Looking for where and how

light dances with nature has evolved into a meditative self-calming practice that quickly soothes my concerns of the day and beckons my busy mind back to the present moment. To my delight, sunlight seems to spot me. On days when I can't seem to shake unwanted negative feelings, I simply look up to find this ever-present friend, inviting me to tune in to the show.

Light was particularly present in my previous Alphabet City apartment. Each morning, I'd wake up to the sunrise bouncing off a nearby apartment building catty-corner to mine and reflecting into my bedroom. Shifting shades of soft green danced on my houseplants as the sun rose higher in the sky. Around 7:00 a.m., a blue jay, whom I named Felipe, would faithfully arrive at my window.

The rising sun gave him a beautiful backlit golden halo. Felipe would curiously peer inside, quickly hide a nut in the dirt of my window box, and soar away. But the image of his feathered presence in the morning light stayed with me, nourishing a calm feeling that I would call upon throughout the rest of the day.

The sun is our source of light, but nourishing light sources also appear in the form of people, places, pets, wild animals, or even plants that guide our growth. These lights can brighten our spirits and bring clarity to what is meaningful and positive. They can also reveal what holds us back and what helps us grow. As a proactive practice, adopt the routine of looking for illumination.

AS A PROACTIVE PRACTICE, ADOPT THE ROUTINE OF LOOKING FOR ILLUMINATION.

As we move into the following affirmations, meditations, and how-tos, let's keep our light sources with us.

BE THE LIGHT

I can be the light that fuels my growth.
I can be the light that turns away dark clouds.
I can be the light that stays bright through
challenges. I can be the light that nourishes
my inner garden of peace.

SHADE

Just as the forest floor holds space for shade,
I hold space for shadows in my life.
For just above the current canopy,
my bright light never leaves me.

NOURISH ME

The light that nourishes nature, nourishes me.

Shadow Art

Begin by breathing in, and enjoy a relaxing exhale.
Today you find yourself in a room with a large bay window.
Against the wall to the left is a couch of worn velvet
in a shade of emerald green.

You lie down, giving your mind and body a break.
Your head rests on a square satin pillow.
Stretch your legs out long, and release any tension.
The couch cushions hold you in a loose embrace.

A well-grown tree lives on the other side of the windows.
When the branches sway, the sun makes shadow art,
decorating the ceiling and surfaces.

The flickers of light captivate your attention.
Other thoughts and worries start to fade as you
watch the shadow shapes on the walls.
Breathe in the light of the day, and breathe out stress.

Follow the lines of light created by wind,
nature, and the sun's luminosity. Let the
gentle movement bring you stillness.

The light and leaves create mesmerizing designs.
Nature reminds you of its vibrant artistry.
Notice now how relaxed and connected you feel,
how worries soften in the sunbeams.

Watch light bouncing off the palm plant in the corner,
and see the white walls turn golden in the changing light.
If you lay here all day, the shadows would move with the sun.

In this moment, you are tuned in to the truth of light,
how its presence has the power to illuminate and shift your world,
lifting you into a state of calm serenity.

Stay with the dancing sunshine.
Let yourself breathe slowly and evenly in,
pause to soak up the energy of light,
then breathe slowly and evenly out.

Twisting Toward the Sun

You find yourself in the presence of two plants
of the same species, with long stems and broad leaves.
Both plants live in matching steel-gray pots
on a wide windowsill, blanketed in sunlight.

Breathe in; pause and let air nourish your body.
Then breathe out slowly and evenly with intention.

Visualize how these plants will grow and mature.
See in your mind the predestined path they will follow.
Stay centered on this image and take a closer look.
Slight variations in growth begin to reveal themselves.

You're charmed by the differences that distance obscured.
You see how each plant grows in its own way toward the light.

The stems and leaves make many minuscule movements
in different directions as they twist and turn toward the sun.
See how each plant takes a similar but divergent path.
Yet both are good.

Notice the way light nourishes the route of each plant,
gifting each the energy to grow, far-flung from where it began.

Look inward and imagine being a plant growing
toward the light. Enjoy and celebrate the light
that supports your journey.

Now exchange your breath with the natural world.
Take another breath in, pause, and breathe out.

Night Lights

The woods are set to sleep soon,
as the brightness of the day
sinks into evening.

Shades of green are still visible,
but those subtle tones will vanish
when the forest falls quiet.
Breathe slowly in and out.

Marvel at this moment.
Watch as the last colors of day
fade to the deepness of night.
Pause here.

There is a silent complexity to the dark.
In its depths you feel at ease.

In the wash of trees painted deep purple,
a light suddenly appears before you
then fades away just as quickly.

Another momentary flash of light shines
boldly to your left. You try to focus,
but the light is gone before your eyes fully capture it.

Then another light flashes at your side.
And as you look to the horizon,
you're greeted by a massive twinkling display.

A glitter of light dances between you and the
distant tree trunks in the shadows.
"It's firefly time," you say softly.

With a new moon and the cloud-covered sky,
light still finds you.
And its show tonight is magical.

Stay present.
Notice the flashes of light around you.
Embrace the happiness of the moment.

And just when you're in the rhythm of looking
for the specks of light in the dark,
the scene quiets.

The lights leave.
Only the outline of nature remains.
Fireflies are fleeting but magnificent,
a bright, captivating presence.

Light lends guidance, even for a little while.
Breathe slowly and evenly in, pause,
and then breathe out.

NOTICE LIGHT

Let's practice noticing light. Pick a sunny day and find a place, either outside or inside, that allows you to see the way sunlight interacts with nature and your environment.

OUTSIDE

- Venture to a natural setting and take a walk under the trees. Look up and see how the sunlight sparkles between the branches and leaves. Bring along a camera, or take photos with your phone, to capture lasting examples of the many ways light mixes with nature.

- Sit down or stand still, and practice patience as you watch for the trees to get caught up in the wind. When a breeze comes, let your eyes linger on the flurry of fluttering leaves, and see the sun sneak through the branches.

INSIDE

- Begin to see how sunlight, both direct and indirect, changes the appearance of your walls or furniture. Position a houseplant to interact with the light. Notice the shadows that the plant and sunlight create.

- Stay present, breathing in and out slowly, absorbing the brightness of light into your day.

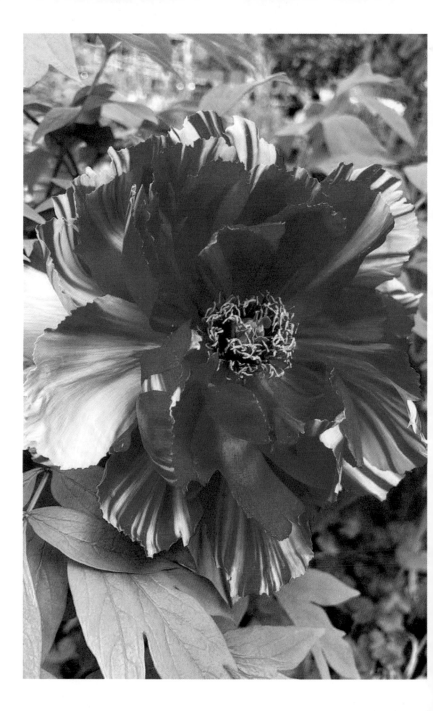

CHAPTER 6

JOY

HOW WOULD YOU DESCRIBE THE SENSATION of joy? Maybe your reply is intuitive and simple, or maybe you find it difficult to define. Joy can feel untouchable and elusive until we're right in the middle of its unexpected arrival. Yet at the same time, it's often found in the smallest, most personal moments. When we cultivate a habit of seeking joy—not with grandiose fanfare, but in the quiet moments that make up every day—we realize that joy is actually available to anyone, anytime, and everywhere.

This is where the natural world comes in. One of the most accessible paths to nourishing daily joy can be through your connection to nature. Think of a time spent with plants or a wild setting that brought you joy. Pause here; remember this feeling.

Feelings of joy work to calm even the peskiest nerves. I marvel at how the instant my mind lets joy take root, it turns on a positive

mental switch. For me, joy's roots are planted deep in my family history and my love of nature. *Joy* was my grandma Dorothy's favorite word, and I cherish these three letters, J-O-Y, and the intense burst of life that she embodied. From a challenging childhood and adolescence to the untimely early death of her husband, my grandma did not live an easy life, yet through all her struggle and loss, she led with joy.

She embraced the living garden of life that she created through her children and, later, her grandchildren. She celebrated what was growing well right before her. She nourished those in her presence and showed through her smile and actions that joy becomes a habit when you're willing to lean into it.

I clearly remember the joy she shared with me when we would find small yellow buttercup flowers in the yard of our family lake house. Her smile never revealed a glimpse of past pain; her eyes glistened with delight for the exact moment she was in.

THE INSTINCT TO SEEK JOY IS ALREADY INSIDE YOU.

As humans, we each have the ability to experience conflicting emotions simultaneously and at varying levels of intensity. This makes us capable of feeling little moments of joy even in the most taxing times. Consider a bouquet of flowers given to someone going through a period of mourning. Even in the midst of loss, this person might still be able to recognize and appreciate the beauty of flowers. Resisting the urge for joy is not in our nature, even when the acceptance of it is tinged with sadness.

Just as joy can exist alongside suffering, it can also create a pathway to gratitude. The instinct to seek joy is already inside you; you merely need to access it. Nourish your joyful inclination as we continue with the next affirmations, meditations, and how-tos.

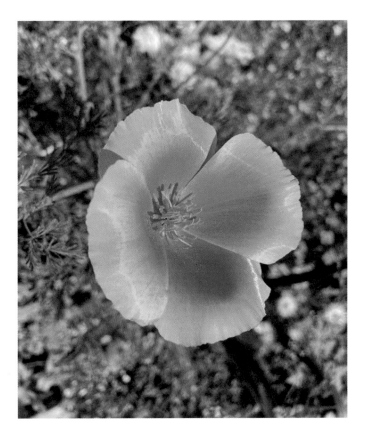

JOY IS

Joy is watching nature bloom in season.
Joy is creating a natural path
to lasting harmony.
Joy is experiencing each moment
without judgment. Joy is present in all
I do, and nature shows me the way.

I AM JOYFUL

I am joyful when I wake in the morning.
I am joyful when a small piece of nature
is part of my day.
I am joyful at sundown when the
natural world darkens to dusk.

ACTS OF WONDER

I will go out into nature and practice
willful acts of wonder.

Barefoot

Breathe in, letting your belly slowly expand with air.
Breathe out, slowly allowing the air to leave.

Bring to mind the experience of a busy day.
Each moment merges with the next.
You're aware of time speeding by,
but you feel disconnected.

Take a pause in the haste.
Allow yourself to imagine you are outside
in your backyard or a natural setting where you
can ditch your socks and shoes. Let nature reconnect you.

See yourself in this setting, and feel the grass cradle your bare feet.
Just moments before, your feet felt constricted and hot in shoes,
but the grassy earth instantly cools them.
You are relieved and relaxed.

Now imagine you start to walk around.
Feel joy for this change as you take meaningful strides.
Feel the supportive ground below your tired feet.
You needed a change. You needed nature.

Stay with this feeling as you slow your steps. Then stand still,
feet together. Feel the grass under your toes and breathe in.
Let your belly expand, and resist raising your shoulders.
Breathe out. Let the air leave slowly
and evenly through your mouth.

Now sit down and get low to zoom in on the grass.
Each blade is delicate; but grouped together, they support you.
In this moment, notice how the hustle of your day has dissolved.
With mindful awareness and gratitude, you can pause to grow joy.

Once more, feeling centered in joy and connected to the present,
breathe in, pause, and breathe out.

Joy Grows

Let your breathing be rhythmic,
going slowly in and out.

Let your mind and body rest
as you access joy through nature.

By noticing nature's fine details and massive expanse,
you can connect to and experience joy.
Awe and wonder are always present in nature.

See a flowering meadow at sunset when the
sky shares layers of pink and orange.

Imagine watching a lunar eclipse or meteor
shower through the canopy of thin pines.

Envision a quiet early morning at home,
just you and the soft light on your houseplants.

Think of an expansive lawn that rolls down
a hill to meet a bustling brook.

Pause here and hold tight to the joy
of being in the presence of something grand.
A broad scope releases the pattern of
self-focus and generates joy.

Now spot small flowers dressed in yellow
that elevate a bland walkway.

Dream up what it's like to meander among roses
and their sweet aroma that lingers as you pass.
Let that scent stay with you. Appreciate it,
savor it, and watch your joy blossom.

Joy sprouts from your subconscious and grows
through intentionally chosen experiences.

Continue to take time to grow your joy
with the natural world.

Breathe in, taking a pause at the top.
Then breathe out, releasing unwanted feelings
and replacing them with joy.

Growing Together

Breathe in the bliss of the present moment.
Breathe out with a softened, peaceful presence.
Sit or stand in silent harmony with the moment.

Now bring to mind a person who is important to you.
Let their face and presence stay central in your thoughts.
Embrace the joy you experience with them.

Envision them standing next to you with a plan.
Today you're starting a project together
that will grow through the summer months.
This is a joyous moment.

You're about to plant a garden
filled with sensitive annual plants
that require more time and care
than you could invest on your own.

But with a partner to share the tasks,
this garden can bear fruit.
See the two of you developing this space.
Adding color, texture, height, and synergy.

You divide up the watering days to keep it flourishing.
Sharing responsibility with someone you trust feels good.
Soon, in all its high-maintenance glory,
the garden begins to thrive.

Feel the excitement of returning after a few days away.
Your partner has kept the garden growing,
and now you delight in the pageantry
of vibrant new leaves and flowers.

Your commitment to the garden and to each other is manifested.
Breathing in, your heart is filled with cheer; breathing out,
your joy builds strong bonds with each other
and the garden.

Fragrant Fantasy

Breathe in and out.
Feel happiness in this present moment.
A warm summer day has turned to night,
and you're outside for a short walk before bed.

Assuming the world will be quieted until morning,
you're surprised by a delightful fragrance.

Looking around, you wonder if someone has joined you.
Maybe another night roamer wearing a scent?

But no one is there.
Your only company continues to be nature.
Joy for this moment of solo discovery encircles you.

The summer blooms that release their essence
during the day give way to the flow of evening aromas.

Tonight you are witness to a fragrant fantasy.
Some scents are soft and sweet.
Others are almost overbearing
in their intense potency,
yet you appreciate the boldness.

The scents enliven your walk and send
calming notes through your mind and body.
Nature shows you the many ways that joy is present
in all you do and in all the beauty, real and imagined.

With your mind open, joy flowers eternal.
Stay with this nocturnal scene. Let it nourish your senses.
And with the joy in discovery, breathe in, pause,
and breathe out.

DISCOVER JOY

Let's make joy a consistent part of everyday life by discovering it in the little things. Right now, feel the excitement of finding all those tiny, easily passable pieces of nature that, when discovered, offer a gleeful surprise. Miniature nature awaits; get ready to zoom in.

- Go where a variety of different plants are growing. Ideally, the space will look slightly busy with natural fullness. Perhaps you can travel to a botanical garden, a blooming meadow, or, if you have a houseplant collection, you can stay home for this one.

- Begin by looking to see what is super small. You can take photos, draw sketches, or capture the details in your memory for later reflection. Seeing beauty and value in the tiniest pockets of nature can bring great joy.

SOME IDEAS TO GET YOU STARTED

- Fuzz on a plant stem
- New buds on branches
- The iridescence of flower petals
- A coiled new leaf starting to unfurl
- Small mushrooms growing on a log
- The tiniest moss spores after the rain

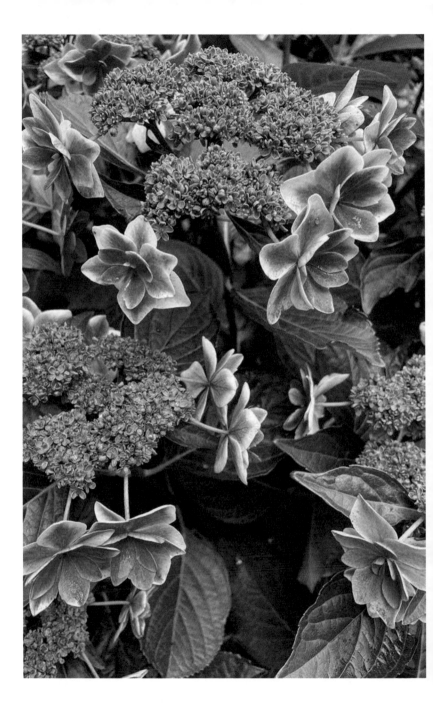

CHAPTER 7

COMPASSION

IN THE ARRAY OF HUMAN EMOTIONS, WE MAY often flip to feelings of fear, anger, and disappointment that can easily dominate our minds. But if we pause at compassion, nourishing an inner softness and allowing it to balance those other feelings, light and joy can begin to break the tethers of negativity that hold us down. The infusion of compassion into our days can liberate our emotional scope and nourish a wider garden for personal progress. Like all aspects of personal growth, developing a capacity for compassion is a journey that begins with simple steps.

At the garden center near where I grew up, there is a trolley cart that offers plants for sale at much-discounted prices. They're all slightly weathered, "imperfect" plants that need a little assistance. The sign reads "Search and Rescue," which is a clever marketing quip that also awakens empathy, a feeling that can be tough to

rustle up and can't be forced. Caring for plants, especially those in need of attention, offers an opportunity to experience how daily compassionate action paired with mindful intention supports our green friends and our own growth.

Showing compassion for nature can grow our compassion for all living things. Even tiny teaching tools like the daily watering of a single fern, or finding a brief pause in the day to examine the health of an orchid's tender petals, can reconnect us to our environment and allow us to care for something outside ourselves. We are less inclined toward self-focus when we keep company with what naturally nourishes benevolent action.

SHOWING COMPASSION FOR NATURE CAN GROW OUR COMPASSION FOR ALL LIVING THINGS.

Compassion needs nourishment, and all nature, even small "search and rescue" plants, can remind people that positive gestures and efforts make a significant difference. Come along with me as we nourish our mindsets with affirmations, meditations, and how-tos that encourage and support compassion.

PLANTING SEEDS

With patience,
I plant seeds of compassion for myself.
I plant seeds of compassion for others.
I plant seeds of gentleness, humility,
and grace to nourish myself
and the world around me.

RELEASE THE CRITIC

I release the critic in my mind.
I regrow my thoughts with compassion.
I pause to be with nature and remind
myself to practice self-compassion.

BLOOMING

When I feel lost,
my blooming compassion for nature
brings me back to a place of belonging.

Compassion Wins

Let your breath travel in and out of your body with ease.

It's the weekend, and you're out to tackle a to-do list.
In the midst of rushing to check off your errands,
you happen upon a large houseplant left on the curb.

Do you stop for nature, or do you walk on?
Someone else with a similar mindset may come along
and, with goodwill, scoop up the plant and take it home.
But leaving it to chance doesn't sit well with you.

Tugged toward action, compassion wins out.
You reach down, pick up the withered plant,
and, holding the pot tightly, head home.

Consider the compassion you can cultivate by caring for a plant.
See how expressing compassion for nature can help
expand the ways you express compassion for yourself.
Feel the interconnectedness.

With kindness, give yourself the groundwork to grow.
Offer yourself encouragement for who you are now
and the person you can become by fostering compassion.
With ease, let your breath travel in and out of your body.

Authentic Listening

Lean into the uncomfortableness that stillness can create.
Breathe slowly and evenly in, pause, and breathe out.

Invite in the silence of truly listening.
Allow your listening to be freed of interpretations.
Allow silence to simply be present,
growing a gateway to compassion.

Picture yourself visiting a park in the early morning.
Only you and today's maintenance volunteers
have found their way into this natural setting.

Sitting at a small green picnic table,
you can overhear their conversations.
Without a clear leader to delegate jobs,
the morning plant-care tasks are debatable.

Your mind wants to fix these question marks,
judge the group's decisions, analyze their ideas,
and let your own thoughts take root.

In this moment, pause and return your active mind
to authentic listening. Pull back overgrown thoughts,
and recoup a true presence.

Notice how the volunteers come together.
Be attentive to their body language.
Pay attention to their exchange of words
as they care for the park and support nature.

You make eye contact and offer a smile.
In this moment of willful listening and presence,
you can see and hear parts of yourself in each of them.

Genuine listening naturally benefits
your daily life and ignites your compassion.
Breathe in; listen to the air entering your nostrils.
Breathe out; listen to the air exiting your mouth.

Nature and Me

Breathe in, pause, and breathe out.

To nature, I say,
May you gain the support you need to develop strong roots.
May you be greeted and warmed by the morning sun.
May you be planted in a place that offers growth.
May you be admired by people but not depleted.
May you be protected from disease and harm.
May you not be damaged by dangerous winds.
May you receive water and prosper.

Breathe in, pause, and breathe out.

To myself, I say,
May I feel calm today.
May I sprout fulfilling newness.
May I be compassionate with myself.
May I receive the care needed to go forward.
May I grow with peace in both mind and body.
May I tend to my thoughts and feelings with kindness.
May I receive ample nourishment for health and happiness.
May I experience times of growth that come with ease and grace.

To all living things, I say,
May we be given space and accept the opportunity for growth.
May we be filled with the right nutrients to carry on today.
May we prosper in our current and upcoming seasons.
May we feel able to change our direction and grow.
May we recover quickly when faced with adversity.
May we feel nurtured by our environments.
May we be protected in challenging times.
May we find paths to growing well today.

Breathe in, pause, and breathe out.

Nourishing Path

Imagine how it feels to start something new.
As with bringing home an unfamiliar plant,
you may need to embrace a longer learning curve.
Invite in the option of gradual change—a slower pace
of compassionate growth.

See yourself nourishing pain with gentle compassion
and creating a safe environment for the past to mend.
See yourself nourishing a space that sprouts
favorable conditions for transformative growth.
See yourself assisting a multitude of seeds
filled with self-compassion to begin their journey.

Know that some will bloom better or faster than others,
but all will aid your growth as you care for your
internal garden and help your mind grow new habits.
Feel how self-compassion can be your nourishing path forward.

Let yourself be okay with the care your mind might need.
With the desire to nourish, blossom, and grow,
breathe in, pause, and breathe out slowly and evenly.

EXPAND COMPASSION

Let's nurture our willingness to express and receive compassion by practicing this ability with the natural world. Tune in to the present moment, letting yourself be awed by nature. Allow this act of wonder to reduce self-importance and self-doubt and expand your capacity for acts of compassion.

When we immerse ourselves in nature, we gain a more expansive understanding of our relationship to the whole. Feeling connected to the natural world supports the positive outlook of being a small but essential part of a grand portrait.

- Take a step outside or travel farther to a natural setting with various plants and flowers. If the current season limits your access to flowers, find a garden magazine or use photographs you've taken. Start to take note of all the flowers. Count how many you can see. Recognize that this is just one small part of the many millions of plants on our planet.

- Repeat this practice by counting plants, bushes, and trees. Marvel at the impressive quantity of natural elements that make up our world.

- Acknowledge your place on this planet as a single living being among the whole. Breathe slowly in and out. Feel comfortable with this position and your place in the world.

- Practice self-compassion by releasing self-criticism and accepting what you may see as personal limitations, failures, suffering, or shortcomings. Instead, show understanding and empathy toward yourself, recognizing the value of your journey.

CHAPTER 8

SELF-LOVE

S ELF-LOVE BLOSSOMS WHEN WE BEGIN TO appreciate who we are and accept our reactions to changing emotions that arise from moment to moment. To achieve self-love, we can foster the marriage of patience and proactive nourishment expressed through actions that support our whole health and growth. The way we each feel most comfortable and nourished with self-love differs widely, but the root goal is to gently hold our own needs, well-being, and happiness at the forefront, limiting how much we sacrifice ourself and health in the pursuit of perceived acceptance or praise of others.

For you, self-love may present itself in simple actions of self-care like a massage or haircut. Or maybe you make an effort to take a relaxing walk in the sunshine, care for your plants, get proper sleep, or allocate extra time to social interactions and activities that are positive.

No matter the actions you take, lasting self-love can best be forged with healthy boundaries. Similar to building a garden or your houseplant collection, this can take time. Whether you're protecting your physical or emotional space, your personal time or passions, prioritizing positive boundaries can enrich your journey and relationships. As you cheer on your small wins, allow yourself to witness the conscious and intentional development of lasting self-love.

I SOW SEEDS OF SELF-LOVE.

Say it with me: "I sow seeds of self-love." With the mental visual of sowing seeds, visualize your hands holding a seedling tray with two rows of three-inch-deep containers. Imagine adding soil to each small space, creating a home for seeds to grow. Now press your finger into the center of each compartment, creating a nourishing place for each seed.

See yourself intentionally putting each seed into its designated area. Gently cover the seeds with more soil. Pepper droplets of water on top and set your seed tray in a sunny, undisturbed spot. With continued care, your seeds will grow well.

Let's say again: "I sow seeds of self-love." Consider, with transparency and honesty, how you would rate your level of self-love. On a scale of one to five, one being low and five high, where do you come in? Wherever you land on this scale, be gentle with yourself. Acknowledge where you are and what, if anything, you want to change to better care for yourself going forward.

As you practice and nourish self-love, it can take root slowly. Your partnership with the natural world will support your

progress. Any opportunity you find to visualize and express your love of nature will nourish your ability to show love toward yourself as well.

Self-love helps close the gap between where you are and where you want to be.

Self-love is energetic, elastic, and extends far beyond feeling good at any given moment. Through conscious continual actions, self-love matures into an abundance of compassion that activates personal growth. When we live our days mindful of increasing our self-love, we can better accept our shortcomings and our strengths. We expand our ability to give love to other people and all living things on our planet.

Together, let's savor self-love through the following affirmations, meditations, and how-tos, each sown so you can benefit from nourishing self-affection.

GROWING LOVE

I embrace a path to self-acceptance,
with thoughts and words free of criticism,
to grow nurturing self-love.

JUDGE NOT

I don't judge nature or myself.
We all have stages of awkward growth,
but I can embrace any moments of doubt
and surprise myself with a sublime bloom.

I AM WORTHY

I am worthy of the confidence
to offer myself forgiveness.
I am worthy of expanding my natural
presence to myself and others.
I am worthy of claiming my choices,
prioritizing my needs, and growing well.

Pinwheels

Breathe in, pause, breathe out, and repeat.
Today, you'll create calm feelings of self-love
by visualizing the beauty of different gardens.

Start by traveling in your imagination to a well-tended garden,
one meticulously cared for and catered to with precision.
See how every fallen leaf is picked up.
Every bush is trimmed for symmetry.

Find yourself in awe of its stylized form,
calmed by its skillfully manicured existence.
Find yourself inspired by the attention to fine detail.
This is a stunning setting, one you will remember well.

Now let your eyes travel to the metal gates of a community garden.
The grit of the sidewalk joins nature in an unexpected burst of life.
See yourself enter and walk on the jagged stone path.

Here, nothing is bought.
All is simply found and configured to fit together.
An old watering can now serves as a home for cut flowers.

Pinwheels in rainbow colors spin among the lilies of the valley.
Porcelain frogs and turtles are placed by large plants
around a pond. This union of knickknacks and
plant life makes you smile.

There's a familiarity that you connect to and understand.
Maybe it's the lack of perfection and uniformity.
Maybe it's the personal, worn-in feel of it all.

Either way, you feel welcomed at this garden,
safe to be who you are. Acceptance lives free here,
and you feel a path to grow with self-love.

Fondly recall the pristine garden you visited earlier.
The dreamlike perfection is appealing.

You applaud the flawlessness, but outside
the garden, perfection is unnatural.

Your life is lived with character, much like a community garden.
Everything you experience is part of your plot,
a gardening section saved just for you.
Hold tight to your plot; tend to it.

Continue to grow in love with it and with yourself.
Take a deep breath in, letting love fill your lungs.
Pause, then breathe out slowly and evenly.

Nourishing Self-Love

Let the feeling of self-love sit next to you
like a dear friend. Feel the comforts of a
friendship that starts with self-acceptance.
Breathe in and out slowly and evenly.

Practice nourishing your self-love
through nonjudgmental observation.
Carrying a tone of care in your thoughts and words,
begin to observe life without sharp edges.

Observe a tulip that has lost a few of its petals.
Yet do not judge the tulip for the lack of symmetry.

Observe a green space where parts have turned to brown.
Yet do not judge places the sun has scorched.

Observe a cluster of blooming chrysanthemums.
Yet forgo judgment, stay present, and resist picking a favorite.

Observe an arrangement of decorative potted plants.
Yet withhold judgment for how it could be done better.

Pausing to breathe in,
you observe the air entering your nostrils.
Breathing out, stay present as the air leaves your body.

If your mind wanders toward judgmental thoughts,
feel that shift, then release those emotions.
Returning to your breath, continue on,
observing yourself with kindness.

Observe the color and texture of your hair.
Yet do not judge it against another's.

Observe the shape of your nails, nose, and ears.
Yet let go of the urge to analyze with a discerning eye.

Observe your height and physical frame.
Yet do not scrutinize how you match up against others.

Observe your unique birthmarks and freckles.
Yet choose not to wish they could be different.

Breathe slowly and evenly in,
then breathe slowly and evenly out.

Through gentle awareness and presence,
you can observe nature and yourself without judgment.
Grow confident in your ability to strengthen your love
for the natural world and yourself.

For the Fun of It

Today you are on a mission to have fun.
Your expectations and objectives
are simple but splendid.

Breathe in, pause, and breathe out.
In your mind and body, let memories of fun flow freely.

Fun can take many forms.
In this moment, as an act of self-love,
you'll enjoy the feeling of childlike fun in nature.

Bring to mind a sunny, warm day.
Imagine heading off to a nearby green space
with a hill that everyone climbs up to see the view below.

The vista from the top is dynamic;
a bold cityscape backs up to
nature in the distance.

Imagine you're at the base of the hill
and start to walk up. It's a hike,
but what awaits you is worth it.

Keep going until you reach the top.
Look out on the great expanse.
Smile, stretch your arms out, and open your chest.

Now the fun begins.
You watch others as they lie down on the grass,
stretch their arms up over their heads,
and put their feet together.

Then, with a cheerful cry,
they roll quickly down the hill
in a chorus of laughter, shrieks, and giggles.

Now it's your turn.
See yourself lying down,
arms overhead, feet together.
With a gentle nudge,
you begin to barrel down the slope.

Rolling in grass feels silly
and makes you slightly dizzy,
but it's fun.
Pure, simple, free fun.

As you roll, connect with the grass below you
and embrace the child inside you. Laugh and enjoy.

You can come back to this hill anytime in your imagination.
Just embrace this nourishing moment of self-love,
and, with a smile, get ready to roll.

See the Sprinkler

Breathe in, pause, and breathe out.
The dawn has nearly arrived where you are.
It will warm up soon, but the air still feels refreshing.

Today you're visiting someone who crafted a stunning network
of nature in their yard. Grass grows like a meandering river
between wide clusters of plants.

You woke up early to help hook up the hoses.
Nature needs a drink before the heat arrives.

You set up three large sprinklers to sway back and forth,
reaching the corners of the garden,
watering everything in their paths.

Watch the droplets blanket nature with nourishment,
and imagine how it would feel to sprinkle
self-love over your whole existence.

Like the plants in a garden, imagine the parts of your life
are spread out before you. Your home, family, friends,
ambitions, your dreams and hopes are all present.

Then see a sprinkler showering droplets of self-love
to nourish all of it, everything you do and dream.
Breathe in, pause, and breathe out.

CREATE HEALTHY BOUNDARIES

Let's practice self-love by recognizing healthy boundaries found in nature.

- Go into your yard or visit a setting that offers a look at plantings amid purposeful barriers. Look around the space and notice where plants stop and a line of mulch or dirt begins, creating a separation between the grass and more cultivated plant life. They are two different parts of nature, protected by boundaries so they may fully thrive in beauty together.

- See how this division nourishes and supports the growth and well-being of each element. By maintaining healthy boundaries, the plants are less likely to be crowded out by grass, and the grass stays in the open and continues to grow.

- Stay present with the idea of creating helpful borders, and see how setting boundaries in your own life can support your positive well-being as an act of personal care and self-love.

Let natural boundaries empower you to believe in the value of establishing your own borderlines. With clear boundaries, you can protect and preserve your personal wellness while guiding others with clarity on healthy and welcomed ways to interact with you.

CELEBRATE SMALL WINS

Let's practice self-care by celebrating little victories in nature and in our own lives.

First, consider some big wins in nature. Maybe it's a pine tree that towers higher than the house below, or a hydrangea hedge with the most incredible fragrant blooms. Big wins are bold and command attention, but let's turn our focus to more humble successes that can go undetected and are all too often unappreciated.

- Any encounter with the natural world is an opportunity to find and celebrate small wins. Head outdoors, or simply go there in your mind, and take a loop around with your eyes.

- Nature's tiny achievements can be a row of flowers still lush with colorful petals late into the autumn, slender plant stems that withstand the wind, or a leaf that unfurls without any rips.

- Each time you notice little victories in nature, pause to practice self-love by identifying and gathering together the small successes in your own life. Maybe you have been waking up more rested, spending less time inside, maybe you recently started exercising more. A tiny, pocket-sized notebook could be your keeper of small victories.

- Consider how powerful it can be to acknowledge the many mini-changes in your life that remain largely silent and unseen by others. The reward is reaped within you. Delight in this private celebration of self-love.

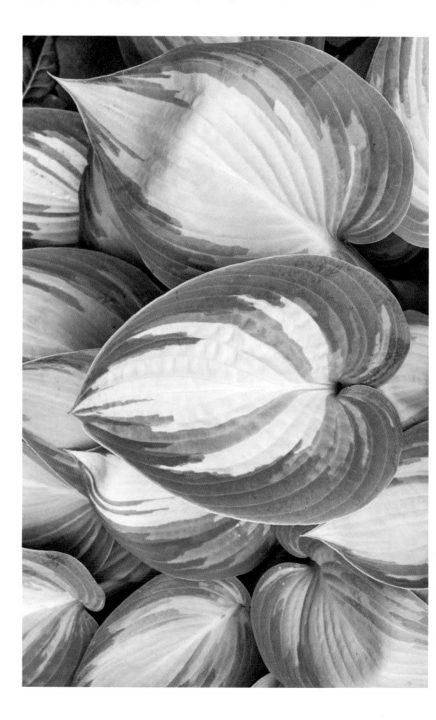

PART 3

GROW

GROWTH IS SYNONYMOUS WITH TERMS LIKE *stretch, extend, lengthen, develop,* and *mature.* The natural world exemplifies these actions, displaying patience interspersed with periods of commanding change. With the guidance of the natural world's patterns, we can learn about our own growth cycles. Perhaps we identify with the late bloomers of fall, like sage and asters. Or we might gain personal insight by noticing the massive waiting game nature plays in spring, holding its cards close, guarding its reveal until each tree bud or bulb is ready to burst into season.

Seasonal visuals can usher nature's choreography of growth into our daily headspace. By living within the framework of nature-focused awareness, our attention is connected to a natural path toward growth and flourishing.

For nature to grow well, it must meet the challenges that arise. The same goes for people. Left unchallenged and unbothered, we may never encounter the opportunity to adapt, grow, and become stronger. When we focus on mindful thoughts and actions, we can develop the physical, emotional, and mental tools needed to embrace life's challenges, cultivating what is necessary to thrive and pruning away what isn't.

Now imagine what a pumpkin patch looks like in early summer. If you check for growth one day and again a few days later, nothing appears to be different. Yet returning to this patch in autumn, you'll see energetic progress. Over time, the plants unveil rapid gains and produce flowers, then fruits in the form of harvest-ready pumpkins.

In a similar way, if we critically monitor our growth on a daily basis, it will become difficult to see advancement. But when we step back with mindful awareness, we see how our growth can be slow but constant like pumpkins. Stages of incremental growth build upon each other, strengthening our mind and body throughout the process.

From the length of our hair and nails to the rapid development of young children and baby animals, physical growth is a tangible reminder that some piece of our existence is always changing. These visible changes also invite us to become more aware of the growth we can't see in our emotional lives.

The groundwork for plant growth starts underneath the surface. Before a plant can develop an enormous flower that hypnotizes our senses, it must first grow a strong and healthy composition in

its roots and stems. Like a bulb in the ground, our foundational growth develops unseen within our mental and emotional space. We support our health and well-being when we grow a secure root structure of mental calm and sturdy stems of positive thoughts and actions.

Before we move on, gently reflect on your ability to grow. Stay alert to the idea that less obvious growth may have the most impact.

Now let's imagine growing in this mindful moment.
Breathe slowly and evenly in, pause,
and breathe slowly and evenly out.

CHAPTER 9

CULTIVATE

A T TIMES, WE MAY WANT TO CULTIVATE SOME-
thing in our lives, but it's not the right setting or timing
to foster growth. Rocky soil—or an equally difficult personal
situation—may not lend itself to the process we're so eager to
begin. And when we continue to plant in the same cultivated plot
over and over again, previously fertile soil can start to get tired.
Looking to reap new outcomes in old habits may yield little of
our desired bounty. If we desire to create growth, there is value in
following our instincts. When things don't feel ripe for progress,
it may be time to move on and begin to cultivate something new.

Even when you can't cultivate the way you want to in action, you
can start by cultivating an idea in your mind. Think like a farmer and
imagine that your livelihood relies on your ability to cultivate crops for
sale. Your life requires this same attention, but that can get sidelined

by the busyness of your days. During gaps in your awareness, the weeds of negative thoughts and feelings can creep back in. Yet when you take the time to be patient and carefully cultivate your thoughts, you can grow in happiness and fulfillment. Through mindful intention and consistency, you can cultivate a strong mental garden and discover that your awareness is a trustworthy place to reside.

Practicing moment-to-moment mindfulness gives you the tools to step back and be an objective observer and to recognize what is going on in your mind and situations. Instead of being overly attached to whatever thoughts or feelings are passing through, including stressful ones, you can be fully in the moment without judging yourself or others.

Caring for plant life is a great way to cultivate your awareness and ability to focus on the task at hand, quieting the noise of stressful thoughts. By exercising this type of mindfulness and living in the present moment, you can stay connected to what you are experiencing right now. You'll notice that whatever happened in the past can't weigh you down, the future isn't intimidating, and anything that creates feelings of stress has less pull.

STAY PRESENT AND TAKE ACTIVE CARE OF YOUR MENTAL GARDEN AS YOU GROW WELL.

If you take the time to cultivate something good outside yourself, you'll likely find that it has a positive effect on your thoughts and emotions as well. Keep this thought with you as we navigate the following affirmations, meditations, and how-tos. Stay present and take active care of your mental garden as you grow well.

TO KNOW ME

I must cultivate a healthy, positive,
and trusting relationship with myself
before planting one with another.

GROW WELL

To grow well,
I must be willing to mindfully plow past
obstacles and stay on course
to cultivate my path.

THE FRUITS

I let the fruitfulness of possibility
guide my growth.

Dig in the Dirt

Today you'll let everything in your life rest
as you venture outside to grow a vegetable garden.

Breathe slowly in and slowly out.
Imagine you are standing
in the grass on a spring day.

Just past the grass is a patch of brown.
You cultivated this square plot of soil last year,
planting seeds for the coming season.

The dirt needs tilling again,
so you'll need to dig deep rows.
Spread them far enough apart so the plants
will have room to stretch out and grow.

See yourself about to begin
but pausing because you have doubts.
Will you be able to tackle this project?
Will you cultivate it toward success?

From experience, you know you can.
You've grown fruitful things before.

Take a breath and believe you're up to the task.
Begin by mapping out a plan in your mind.
See where you'll design the rows for planting.
And with your imagination fully engaged,
run a mental time-lapse video to show
what this space will become.

Small green plants will grow up and
bloom into a delicious summer harvest.
What you care for and cultivate today
will bloom in the months ahead.

So take up your gardening tools
and, with a trusting mind, begin.

Mindfully break up what was there before.
Create new paths for what comes next.
Your arms feel a little sore, but it's a good sore.
You feel connected to your body and the earth.

Turning over the ground and digging row after row
is a repetitive task that helps you to stay in this moment.
By loosening the soil on the surface of the vegetable patch,
you may see parallels in your own life.

Imagine how it could be helpful to loosen up
and break through thoughts that hold you back,
to sow new seeds that help you grow.

Pause to envision the potential energy of garden-fresh growth.
Breathe in slowly and evenly, then breathe out slowly and evenly.

Foster Newness

Breathe in, pause, and breathe out.
Lean into the idea of living a carefully cultivated life
filled with the meaning and contentment you desire.

Encourage a natural yearning for newness,
and watch as plentiful growth
springs out.

With examples in nature as your guide,
picture yourself working the soil of each day,
taking care to enrich each moment.

Trust in the value of cultivating awareness.
Allow yourself to believe in your ability to stay focused
and devote the time and attention needed to grow.

Breathe calmly in and out. Cultivate what is best
within you. See yourself growing from your
experiences in love, life, work, and play.

Cultivate inner optimism and gratitude
to overcome negative thoughts and ruminations.

Cultivate a mindset that honors your strengths
and provides a shelter of support while taming
the critics, even yourself.

Cultivate a positive perception of yourself.
Tend to it and champion your progress
to benefit your health and well-being.

Cultivate a safe space for your mind to flourish.
Cultivate a safe space for your physical being.
Cultivate your inclination for intentional kindness.

Breathe in, pause, and enjoy a relaxing exhale.
You are cultivating feelings of calm that will endure
to look after you and your future self.

Wildflowers

Breathe in and out.

A gated patch of undeveloped land is nearby.
It's privately owned, but you have the opportunity
to grow something there.

You decide on wildflowers.
They've been on your mind since some
caught your attention on a weekend walk.

This small plot of land soaks up the sun all day,
making it a match for a mini wild meadow.

You start by raking the rough soil.
It's less than ideal for many plants,
but it will be fine for wildflowers.

You pull up weeds until only
dark brown dirt fills the space.
Take a slow, even breath in and out.
You're ready for a grand spreading of seeds.

Neighbors pass by and wave hello.
Perhaps they wonder what your plan is for this space.
You wonder too and look forward to this experiment.

Returning with a bucket of seeds,
you sow them broadly across the empty
space to reach each corner of the plot.

Next spring, you'll see the results of your efforts.
For now, you can simply stop by the gate,
be present with the space, and wait.

Before the seeds sprout,
something in your life changes that takes you
away from this place and your wildflowers.

Knowing that you won't get to see them grow,
you let your mind move on, staying centered
on what is next for you.

Breathe in, pause, and breathe out.

Months later, as the spring sun begins
to shine warmly, you get some news.

Your wildflowers have arrived.
Growing tall and strong, they are thriving.
Warmed by the sun,
they dance in a pleasant breeze.

Through photos and excited calls with friends,
you reconnect with your old community.
The beauty of your idea has come to life.

Cultivated out of your curiosity,
this once glanced-over space now gifts cheer
to all who pass by and grows their interest
in the beauty and charm of wildflowers.

Neighbors stop to admire nature's show.
They peer through the slots in the gate,
or look on from the rooftops.

You've engaged others in nature, and their stories
connect you to your plot of wildflowers.

The land you cultivated on a whim
turns out to be useful and loved.
Your actions grew into flowering splendor.

With appreciation for the wonders of nature,
celebrate the excitement of cultivating something new.
Breathe in, pause, and breathe out.

CULTIVATE WITH ACTION

Let's cultivate our link to nature through active learning and physical connection.

Are you on a first-name basis with the nature in your area? Using the aid of a plant catalog or an online search, start to learn the names of the trees, plants, and flowers in your neighborhood or nearby park. Spend some time researching and then go out and find examples.

The goal is to cultivate an understanding of the nature that coexists with you by learning to identify it. When we can put a name to something, it gains importance. You can also cultivate your link to nature through physical touch. Go to a setting where you can tangibly interact with nature.

- Try to juggle or balance small rocks.

- Press your hand on the bark of a tree.

- Lightly stroke a silky flower petal between your fingers.

- Find different sticks, slender and thick, to carry with you.

- Brush over the top of grass with your outstretched fingers.

- Pick up seed pods and investigate where they open and what's inside.

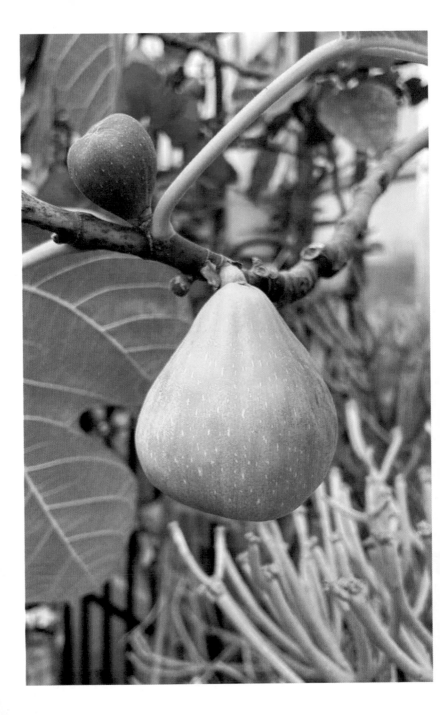

PLANT

I F YOU WANT TO PLANT A PIECE OF NATURE today, you'll need water, dirt, maybe a small shovel, and a plant or some seeds. Then you'll need to consider the light situation. And if you're not digging in the earth, you'll need a pot.

What if you want to plant progress in your own life? How would you begin? In the growth journey toward creating the life you want, small seeds of newness are planted each day. Through practicing mindfulness, you are taking small steps that will eventually yield big results as you release harmful or useless outlooks or lifestyles and redirect your mind and energy toward productive growth.

WHEN I NOTICE REPETITIVE THOUGHTS THAT DON'T SERVE ME, I PLANT NEW SEEDS.

When I notice repetitive thoughts that don't serve me, I plant new seeds. Sometimes I'll pause whatever I'm doing to go outside or make a cup of green tea, focusing my mind on nature and reminding myself to stay planted in the present moment rather than the past, no matter how hard the old patterns of thinking try to sneak back in.

The intentional new seeds you plant throughout the day will take time to grow, but with commitment and care, you will start to see progress. Your seeds of change will sprout through the soil. A slight tint of green will appear among the brown. It takes time to get to this place, but if you keep planting one positive seed after another, by the time you see the first one sprout, the others will be just under the surface, developing, transforming, and waiting their turn to join your blooming garden.

Imagine purposefully planting yourself in soil that grounds you to the present moment. With this anchor of mindful attachment, take a cleansing breath in, pause, and breathe out slowly and evenly. Join me for the following affirmations, meditations, and how-tos as we enjoy feeling well-planted.

DIGGING IN

Even in rugged soil,
I can dig in and grow new roots.

I PLANT

I plant trust to grow.
I plant patience for myself.
I plant grace to stay grounded.
I plant kindness for the process.
I plant tenderness for myself and others.

GROWING AGAIN

When challenges surface,
I remember to pause,
clear out what holds me back,
and replant myself in a mindset
to grow well again.

It's Planting Day

Breathe in, pause, and breathe out.
Today is a planting day for you.

It's time to reflect and look forward.
Imagine kneeling on the ground.

Your knees sink into the soft grass;
a trowel is in your hand, and
empty soil is before you.

You're about to plant a bunch
of tulip bulbs to enjoy next spring.
With a variety pack of colors and shapes,
you are eager to witness the many ways
the flowers will bloom.

Now dig down deep with your trowel.
Gently place a bulb in the hole, pointy side up.

Water well and replace the displaced soil.
Pat the dirt in place and gently push down.

See yourself repeating this pattern with the next bulb

and the next. Let other thoughts gently pass by
as you focus on planting. Stay present,
and experience how it feels
to plant the tulip bulbs.

When your bulbs are all planted and resting
below the surface for winter, you wonder
what their flowers will look like come spring.

In life, just as in nature,
you must be willing to wait.
Good growth takes time.

In this moment, cultivate hopefulness.
Breathe mindfully in, then breathe out slowly and evenly.

You and the River

Breathe in nature; breathe out stress.

Today you've planted yourself in the middle of a
nature preserve where a narrow but active river runs.

You watch the water as it hurtles past,
tossing out a spray to cover the vivid
green moss that grows along the banks.

Sitting on an outcropping of stones,
you survey the dense clumps of moss with your hands.
When you apply a little pressure to nature's flooring,
the spongy moss reflects that pressure,
but as your fingers move away, it quickly rebounds.

This new experience grows your understanding of nature.
You're pleased that you took the time to get outside today,
and happy you decided to plant yourself in this setting.

As you pause by the bank, let your hand travel
from hard, wet stones to the mounds of soft moss.
Your whole being feels grounded and secure.

Focus on this sensation,
breathing calmly in and out,
knowing that at any time,
with a mindful pause,
you can replant yourself by the river.

I Am Ivy

Take a slow, even breath in, then let it out slowly and evenly.

In this moment, imagine it is early spring
and you are green ivy attached to the side of a
stone castle in the countryside.

The structure has expansive walls,
giving you the opportunity to climb
higher and higher.

Take another breath in, and let it go slowly
and evenly out. Carefully begin to climb upward.
Notice the challenge of traveling in a straight line.

As a vine, you first crawl across the wall,
sending out shoots that cling
tightly to the stone.

You scale the surface in a diagonal motion.
Left, then right, back and forth like a zigzag.
Stay with this pattern as your trail of leaves
begins to cover the castle wall in greenery.

The sunshine and your roots planted well
in the earth below support your journey
through the warm months of summer.

The direction of your growth may not be
what you expected, but pressing forward
you create a beautiful journey.

By autumn, your leaves turn to an electric shade of red,
covering the entire castle. Like ivy, you are capable
of dramatic resilience and growth.

PLANT

Hold fast to the optimism of climbing plants.
While your path may not be straight, you are
always capable of continuous growth.
Breathe in and out.

Where to Grow

Breathe in and breathe out.

See a plant thriving in full sun,
expanding toward greatness.

It soaks up the sun's strong rays.
Each leaf, stem, and flower is illuminated.

Now picture a plant growing well in partial sun.
Maybe it takes in morning sunshine
but grows in shade by noon.

Or maybe you see a plant that basks in
the strength of midday sun but is soon shaded by trees.
These partial-sun plants are also in the right setting to grow.

Now move your mind to a full-shade situation.
It's dimly lit. The sun isn't reaching
these plants, and they love it.

Stay present to how different plants
grow best in different places.
Then pause to breathe in and out.

Connect to yourself and to
what type of ground is best for you to grow.

Do you desire bright light, partial shade,
or full shade to feel grounded and secure
in your thoughts and actions?

Perhaps your selection echoes your personality,
revealing that you're drawn to privacy, or to living more exposed.

Imagine being in the right place or situation
for you to plant productive growth.
Breathe in and out.

PLANT PROGRESS

Let's plant seeds that grow our personal progress.

- Grab a seed, a small paper cup, and some dirt. Add a handful of dirt to fill up half the cup, then press a little hole to provide a home for the seed. Consider seeds like basil, mint, rosemary, or oregano that, when grown, provide aromatherapy benefits.

- Plant the seed, water lightly, and cover nearly to the top with more dirt. Water again and place the cup on a windowsill.

Pause and ask yourself, "What in my life would I like to plant and watch grow alongside this seed?" Maybe it's a relationship, a new job, vacation plans with people you love, or a path to better health. What would you like to plant today and commit to intentionally growing? Just as this seed must germinate, root, and eventually rise, so too can the ideas, hopes, and happiness that you would like to grow.

On the day you plant this tangible seed, write down what you'd like to plant and help grow in your own life. Consider keeping this note next to your paper cup planter as a reminder and game plan. Take a moment to appreciate the value of planting.

PLANT POSITIVITY

Let's plant positivity in our mindsets by being present to where plants are placed.

The ideas below will help you see the many places in regular life where people have planted pieces of nature for the benefit of others. Choose a few to check out today, and keep the others in mind as you come across them. When we least expect it, we can spot purposely planted nature.

- Pharmacy
- Restaurant
- Gas station
- Doctor's office
- Grocery store
- Bank entrance
- Convenience store
- Coffee or ice-cream shop
- Curbside of residential city street
- Gateway to housing development
- Gift shop
- Clothing store
- Entrance to corporate skyscrapers

Seek out some of these plantings. Walking or even driving by their presence can plant feelings of happiness, hope, and calm in your mind and body.

CHAPTER 11

PRUNE

SAYING YES TO ANYTHING MEANS SAYING NO to something else. In order to grow anything, we must also be willing to prune. The act of clipping away at something with confidence takes practice, so a sense of unease is natural. However, it's important to embrace that feeling while also being excited about what lies ahead.

Just as your garden and houseplants require pruning in order to thrive, the same goes for the parts of your life that aren't growing with you. To prune is to gain the opportunity for something to reach its full potential. Sure, it can be scary to face the unknown and unfamiliar, but it can also be dramatic and exhilarating.

Take a moment to visualize a period in your life when something you had come to rely on was taken from you; perhaps you lost a job, a relationship ended, or you had to move out of a home

you loved. Consider how this absence required you to adapt and grow stronger. Now think about how far you've already come in your growth journey alongside nature. What would it feel like to enter a season of aggressive shearing? What if some unforeseen circumstance threatened to trim away almost all your recent growth? You'd have to begin from square one, only now you are equipped with tools you didn't have before. It's a daring moment, but with courage you can train your mind to regrow with vigor.

Consider the annual practice of winemakers who clip back nearly all the new growth from the previous year. Completely trimming off what had just grown feels counterintuitive, but it's an important step and is key to the success of the next season's harvest. This practice results in fewer grapes, but ideally those that do grow are of higher quality. Without pruning, the bushes would yield more grapes—thus, more wine. But in this surplus, the quality can suffer.

Try to relate this to your own life. Having a surplus doesn't always correlate to having what you actually want and need. If cutting back is necessary, the natural world offers inspiration and reassurance as you begin a spirited season of pruning. This can mean letting go of commitments, projects, or opportunities, even some you enjoy, to make room to restore your energy. Healthy pruning can also mean allocating less time to people or situations that aren't growing with you.

HAVING A SURPLUS DOESN'T ALWAYS CORRELATE TO HAVING WHAT YOU ACTUALLY WANT AND NEED.

As you consider pruning, tune in to

the timing. If you prune too late, you'll be reacting after the fact and not performing a forward-thinking act. Pruning demands the willingness to be forthright, making choices before you can see the results. When you understand a yellowing leaf is weighing down the plant's potential, you can start to see the yellow leaves in your own life.

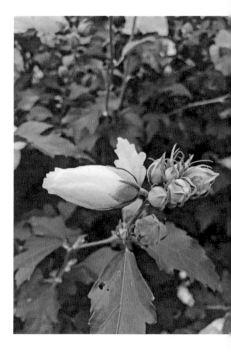

Envision being willing to prune for progress. This requires you to really trust your gut, welcoming in selectiveness, choosing yourself, and pruning away what doesn't help you to grow.

Cutting off new growth or timely endings in nature is necessary. It may not feel right, but the benefits grow bigger with time. As we go into the next set of affirmations, meditations, and how-tos, remember that to prune properly, we have to be gutsy.

NEW SHOOTS

I have the power to prune away
what is no longer growing,
making room for new shoots.

PRUNE FORWARD

When I grow out of balance with myself,
I pause to trim away distractions
and reshape my way forward.

LIKE A FARMER

I'm responsible for my own growth.
Like a farmer with a fruit tree,
I regularly prune the parts
that won't support abundance.

Clipping Away

Breathe in, pause, and breathe out.
Bring to mind a large potted plant
with notable new growth.

The plant is mostly a healthy shade
of hunter green. Yet you spot some
parts that look worn and discolored.

Center your attention on two leaves
that have transitioned to yellow-green
and will soon fade away.

These leaves have entered
a captivating stage of beauty,
and letting them go feels harsh,
but you must prune to protect.

When the yellowed leaves are gone,
the plant will direct its nutrients
to the green, healthy leaves.

With a reassuring breath in and out,
visualize taking up shearing scissors
and giving the withering leaves a chop.

By pruning, you release what pulls on the
plant's potential. You support its
well-being and longevity.

Allow the image of clipping away the tired leaves
to remind you of similar leaves in your own life.
Maybe something feels heavy and burdensome.
Maybe it doesn't align with your purpose and passions.

There can be parts of your life that do not serve
the growth, vitality, and harmony of your whole being.
Imagine cutting back what doesn't help you grow.

Notice how caring for a plant,
taking the time to protectively prune,
shows you ways to better care for yourself.

Breathe in as you prune away;
breathe out as you encourage
and energize new growth.

Whimsy

Take a cleansing breath in and then slowly breathe out.
Invite your mind to be quiet as you wander off
to a fanciful topiary garden. The grounds are quirky
and extravagant. A smile begins to curl up
the corners of your mouth.

Here, the shrubs, bushes, and small trees are shaped like animals.
You marvel at giraffes and bears, butterflies and a
pod of dolphins jumping out of ocean waves.

Designs of shooting stars, clouds, and a rainbow
catch your attention. All that lives here is whimsical
and tended to with studious precision.

It's midmorning on a weekday.
The space has few visitors.
It's time for gardeners to clip away at their masterpieces.
You watch intently, interested in the art of proper pruning.

With great finesse and precision,
the gardeners snip small sections
and shear away large parts.

You're amazed by how they decisively remove
good growth to support what is even greater.
The self-trust and clarity they display are contagious.

PRUNE

Stay present to the purposeful practice of pruning.
Allow yourself time to learn from others.
With intention, pause to breathe in and out.

First Blossoms

Let your imagination be limber,
your mind expansive, and your body
calm in this moment. Breathe in and out.

Imagine you are a spring-flowering shrub.
See how your first blossoms of the
season bloom boldly.

Admire their glory.
Observe their presence and striking beauty.
Breathe in their fragrance; let it bring you calm.

Stay present to their beautiful blooms,
accepting that once their moment
begins to pass, you must be ready
and willing to let go.

When splotches of discoloration
signal natural decay, it's time to prune
to protect the plant and allow it to thrive.

These first losses can feel
unfortunate and possibly unsettling.
Yet you mindfully embrace the purpose.

Now let your thoughts move forward.
See what clipping away can do
for the future.

Breathe in and breathe out.
Imagine the blossoms of the next season
and their even grander glory.
See nature and you, thriving together as one.

Rows of Roses

Breathe in the aroma of a single rose, then breathe out.
You've fallen in love with gardens of roses.
Tints of red, yellow, and pink shout color
amid off-white alabaster.
It's the season for remarkable rose blooms.

There are many gardens to visit today,
so you're off to explore the first rose-colored world.
On your way, pause to breathe in and breathe out.

Entering the garden, you instantly feel
the vitality of growth all around you.
A sweet scent of violet and lemon
catches your attention.

All around you are healthy rosebushes
producing blossoms and a surplus of new buds.
This extra growth can be joyous
yet draining to the whole.

You observe a gardener making her rounds.
She senses your interest and stops to chat,
sharing with you that, left untouched, almost all
the roses would survive but few would thrive.

It's her tough job to pick sides and prune away
good buds to save the energy and
nutrients for the very best buds.

Without mindful pruning,
no bud can truly bloom to its fullest potential.
With the necessity of pruning in mind,
breathe in, then pause and breathe out.

Start to see parallels in your own life.
Perhaps you've grown in many directions,
and a little pruning could help your best buds grow greater.
Imagine blooming well as you breathe in and out.

START PRUNING

Let's study ways to prune parts of nature and translate these different styles of pruning to benefit our own lives. Below are three common forms of pruning. Read through and visualize how each is performed.

- *Pinching*. The simplest form of pruning involves removing terminal buds that grow from the tip of a shoot. This pruning encourages the plant to develop bushy growth instead of spindly offshoots.

- *Heading*. These cuts prepare a plant for more dense growth by taking a more vigorous approach to pruning by cutting farther back on a stem, in between a dwindling flower and healthy growth.

- *Thinning*. This technique involves removing whole branches near the meeting point of a larger branch to uphold the general shape while removing bulky branches.

Now take this plant practice and apply it to human terms. Completely pruning away all progress, all new growth, is not usually necessary. Cutting back small portions can yield big results.

- Look at your own life, focusing on the main categories of home, family, profession, lifestyle, and goals. What could use some intense pruning to grow your happiness? What areas could use only minor clipping? This week, take at least one active step to start pruning what needs to go. Consider selecting a small personal or professional commitment that you can let go of to make more room for your new growth.

THRIVE

T O THRIVE IS TO FLOURISH, TO GROW VIGOR-
ously and luxuriously, but not all at once. Wishing to thrive
in all areas of life at the same time is like asking nature to bloom
in unison. The effect would be spectacular but fleeting. Nature's
ecosystem is intricate and delicate; thriving means that all the
different aspects of this system must rely on what the changing
seasons give and take away in perfect order.

Much like plants rely on natural balance within their environ-
ment, the art of thriving in your own life is about living an engaged
lifestyle and managing your energy as you mindfully determine
how much to give and how much to take away. Nature can be your
resource to restore and maintain your energy while providing
examples of how to thrive no matter what comes your way. Being
able to confront undesirable circumstances, agile in our thoughts

and actions, and being open to adapting our behaviors when new needs arise are all crucial to our personal growth.

Once, while on a holiday in Mallorca, I stayed in a hotel room with a small balcony that looked out over the town. Local life was everywhere, vibrant with color and energy yet rooted in the rhythms of every day. The people and their plants spent warm days and languid evenings on balconies just like the one outside my hotel room. Most nights, after the heat of the summer day had passed, a woman would momentarily appear on a balcony directly across from mine to water her plant. From my viewpoint it looked like some dark green shrub living in a yellow pot.

By the end of my time there, the plant was a blooming yellow hibiscus, and many of the stems had found their way between the six-inch spaces in the railing that looped the balcony. Stretching far beyond their boundaries, the plant's stems reached toward the bright sunshine to help it to grow well.

NATURE THRIVES BECAUSE IT FINDS WHAT IS POSSIBLE IN EACH MOMENT.

Nature thrives because it finds what is possible in each moment; it seeks to fulfill its intuitive needs. That may mean it needs to weave around, creep over, or sneak under whatever stands in its way. Unexpected obstacles may challenge nature's path, but when the goal is to keep going and growing, there is always a new way forward.

Nature lives and thrives in the present moment, and we can too. Embrace the ongoing opportunity to seek growth and fulfillment with the following affirmations, meditations, and how-tos.

IN-BETWEEN

Thriving is feeling comfortable with myself.
Thriving is adjusting to fast or slow growth
and the moments of pause
that sprout up in between.

FLOURISH

I encourage myself to press forward
toward vigorous blooming growth,
flourishing without doubt or hesitation.

REROOT

I thrive when I respond mindfully
to challenges and reroot
to recover quickly.

I Will Thrive

Sometimes you must divide to thrive.
Let this thought stay with you.
Let it grow in your mind as you
breathe in and breathe out.

Keep a keen desire to thrive,
and say out loud, "I will thrive."
Feel it invigorate your being.

Now imagine you're in a plant-filled yard,
helping an old friend to revive the landscape.
You're not sure what this event entails, but you
volunteered and showed up.

It's been awhile since you last saw this person,
and nerves creep in as you wait outside.
From the close bond you once experienced,
you've gone in different directions and thrived separately.

You see your friend walking toward you
and exchange smiles. Your unease begins to fade.
Together you'll separate clusters of crowded
hosta plants that need to be replanted.

By splitting up the plants,
you help breathe new life into their existence.
As the summer season unfolds, this perennial act
of care will help each to thrive.

With attention, you dig up a clump of hosta,
including a large section of fleshy roots. Brush
the soil away from the root structure to reveal the
thriving underworld of nature.

With gentle pressure,
separate the cluster into two.
Then dig new homes for the plants
and place each in the ground.

Add soil around the sides and water thoroughly.
You'll repeat this routine many times.
Feel your body and mind get into a rhythm.

Your interactions with nature today show how living things
can benefit and flourish from splitting off, going in different
directions, and finding their own way to thrive

Breathe in, pause, and breathe out.

Free to Roam

Breathe in nature, and breathe out stress.

Let a wave of relaxation travel through your body.
With a calm, centered mind, imagine
that you're in a wide-open space in nature.
Thriving requires connection.

Maybe it's a field or expansive park,
a beach or desert.
Scroll back in your memory
to a place you've been,
or picture somewhere
you would like to go.

Reconnecting with nature helps you flourish.
Determine your wide-open wonderland,
and go there in your mind.

Notice yourself standing still, and invite your legs
to explore. Take big steps forward.
Feel connected to your body.
Focus on walking.

Be aware of your feet and look into the distance.
What do you see? Is it a line of trees on the horizon?

A body of water or rocks?
What's out there?

Focus on the small details, then take in the whole scene.
Feel joined to nature and continue to walk,
expanding your stride.

Maybe leap, jump, or dance.
Feel a cool wind bounce off
your face and breeze by.

In this wide-open natural setting,
you see plenty of room to roam.
Link yourself to nature,
recognizing your unlimited opportunity
and your ability to thrive. Take one more deep breath in,
pause with nature, and exhale.

Full Bloom

Open your mind to the image of a thriving garden
that flourishes with growth, health, balance,
and alignment. Pause to welcome thoughts
that ripen your mental flexibility, your adaptivity.

Pause to witness nature in its premier state,
full of its calming essence and energy.

Pause to study a garden's steady progress.
See plant life in its prime, bursting with brilliant fruit, flowers,
and veggies. Note the conditions needed to thrive.

The stage is set for a plentiful season,
and all around you lives vivacious growth.

Now envision the feeling of living a well-balanced life.
See yourself thriving in both health and happiness.
Hold this thought close as you breathe in
and breathe out.

Draw in what it feels like to be content
with yourself and satisfied with how you can
thrive professionally or personally.

Release any thoughts that feed rigid thinking,
limit you, or add undue pressure.
Feel in unison with yourself.

Breathe in and breathe out in the full
bloom of your own essence and energy.

Limitless

Breathe in slowly and evenly,
then breathe out slowly and evenly.

Notice the flexibility and expansiveness
that increase in mind and body through
concentrated, intentional breathing.

Let your breath guide your mind
into a thoughtful space of pliable growth
where you can thrive.

Start to visualize yourself in the presence of a beautiful plant.
See it growing close to a fence in a spot that lacks light.

This plant could thrive better on the other side of the fence.
Observe how its current setting creates obstacles,
yet with flexibility and expansive energy,
nature keeps going.

Imagine how, over time, this plant can resist limitations
and switch strategies. You embrace its agility.

With age, the plant begins to grow under the fence
and over the top; it stretches and elongates toward
a better path to thrive.

Let your mind be agile like this plant.
Let it be open to new options and course changes.
Let your body feel ready and able
to change and thrive.

Breathe in with renewed energy.
Breathe out with calm resolve.

ENJOY EVERY DAY AND THRIVE

To thrive, it's important to practice enjoying our daily journey, which can start by waking up mindfully with plants. A commitment to actively connect with nature in the morning helps you meet the challenges of each day and embrace every moment, attuned to what helps you to thrive.

- Start with a plan to get a good night's sleep so you can wake up in the morning rested and alert. Create a restful atmosphere by dimming harsh overhead lights and staying away from screens for at least thirty minutes before you go to bed.

- Set your alarm to ten minutes before you would regularly get up. When it goes off in the morning, resist snoozing and immediately let yourself connect with nature. Position a houseplant within your sightline, or sit up to look out your window. Let the color green fill up your early morning thoughts, bringing calm to your day ahead.

- Pause to acknowledge the new day. Be aware of yesterday without judgment, and feel gratitude for what new opportunities today can offer. Before your mind gets busy with its tasks and assignments, let yourself be still. Breathe in this moment that is completely yours.

PART 4

PERSIST

CONSIDER THE GIANT SEQUOIAS THAT ONLY reproduce by enduring fire when their heated cones open up and shower seeds on the forest floor. When we observe nature's strength and persistence, we're reminded that we, too, possess these resilient virtues. With nature's guidance, we can persist and prevail through the anxiety, stressors, and changes that create tumultuous conditions in our own lives.

From plants growing between cracks in city sidewalks and fir trees sprouting through rock outcroppings along a highway, to flowers stretching up from the dried lava of an exploded volcano, nature can inspire us to take on obstacles and find a favorable way forward.

Just as a plant bent down after a driving rainstorm perks back up when the sun warms the earth, we can also rebound from difficulties and continue along a positive path. In challenging times,

we must remember that we are persistent parts of nature. We all have the natural ability to be flexible but strong, elastic in thought and mindful in action.

Forging past barriers can feel tiresome and difficult, but we can change the narrative by celebrating our own perseverance as we would a forest returning slowly after a violent wildfire. Bouncing back takes desire, diligence, and time. We need to be gentle and patient with ourselves.

Consider for a moment a houseplant that has lost most of its root system. The opportunity for regrowth appears slim. But if even a few thin strands of roots are present, the plant can be placed in a bowl of water and given the opportunity to revive. After a couple of weeks, small signs of new root growth can begin to appear. With time and proper nutrients, the plant will continue on its course to growing well.

In difficult times, we can recognize the need to pause, process what has occurred, and reorganize our thoughts to respond in ways that support a healthy mind and body. Harboring heavy negative emotions holds us down and keeps us emotionally stuck. When we're mindful of nature's resilience, we can learn the value of absorbing and then releasing negative feelings and mental roadblocks and resolve to continue on a hopeful path.

We can consciously plant positivity into our thoughts and actions through the affirmations we practice together here. Speaking affirming words is an effective tool to support persistence. And when we need assistance to focus on the good and become resilient, nature is here to help.

If a tree loses a limb in a thunderstorm, the rest of its body can still continue to grow. Even when a whole tree is cut down, if its roots are still secure in the earth, a new tree can sprout up from the forgotten stump. Nature adapts and moves forward. The cycle of ocean tides takes the water out and brings it back into low-lying marshes and wetlands to nourish seagrass and support wildlife.

Around the world, wildflowers come back season after season, sowed by the wind, pollinated by bees, and propagated by birds. Nature works together to persist toward a positive outcome.

No matter where we are or what is going on in our lives, when we approach the natural world with mindful awareness, it's easier to reflect nature's persistence and see ways to be more resilient in our thoughts and actions.

> Let's feel persistent in this mindful moment
> and breathe in slowly and evenly, pause,
> and breathe out slowly and evenly.

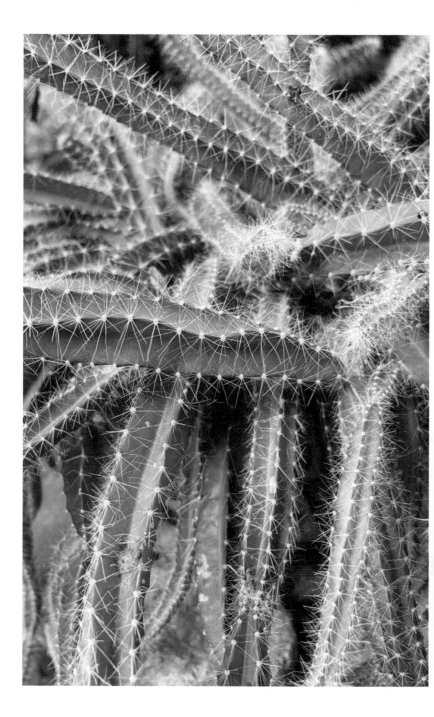

CHAPTER 13

ANXIETY

W E'VE ALL FELT IT—A SENSE OF TENSION, apprehension, and unease. It's not pleasant or planned, but anxiety happens. When it does, our minds are often flooded with past regrets or future concerns, which only lead to more anxious feelings. Luckily, in the midst of even high anxiety, with mindful understanding of its presence, we can control our response and draw strength and inspiration from nature.

Consider how plants deal with the stress of a summer drought or untimely frost. They remain rooted in the present hardship, responding to circumstances they can't control, working through seasons of challenge and pushing through to the better days ahead.

Equanimity is rooted in all of us. Nature can help us reclaim it. Like a tightly coiled leaf unfurling, we can unknot anxious feelings to allow space for tranquility and a positive mindset.

Often, we allow anxiety to grab hold of us before we recognize what has happened. It sneaks up on our consciousness and makes trouble. Negative thoughts race and clatter through our minds, creating a tangled web of mental white noise.

Anxiety can spring from health concerns, financial hardships, changing relationships, self-doubt, and unfamiliar surroundings and events. Fear of the unknown, rejection, and disappointment can be hard to release from your mind. These things can darken an otherwise sunny day and wipe out whole blocks of time from your calendar. Even when you know there's nothing more you can do to change the situation, your hopeful mind can balk at the prospect of failure and loss. Even if there is a positive path forward, you might not see it if you are cloaked in anxiety. Fortunately, a connection to nature can tackle that anxious sprawl and help you persist with mindful awareness of where you are and where you want to be.

EQUANIMITY IS ROOTED IN ALL OF US. NATURE CAN HELP US RECLAIM IT.

As a plant purposefully leans into the light, you can consciously center yourself with nature to release self-doubt and fear, focus on your breath, and lean into what lightens your mind and body. This is when an intentional pause can be most powerful.

You can invite in what nurtures your growth and turn away from worry and hypervigilance. When you let the healing power of nature protect you and build up a reservoir of calm, you are better able to guard your peace against the intrusion of anxious feelings.

The following affirmations, meditations, and how-tos can strengthen your ability to quiet unwanted thoughts and restore inner equanimity. As the energy of the sun restores plants, we can use the power of an intentional pause to restore our inner peace and optimistic outlook.

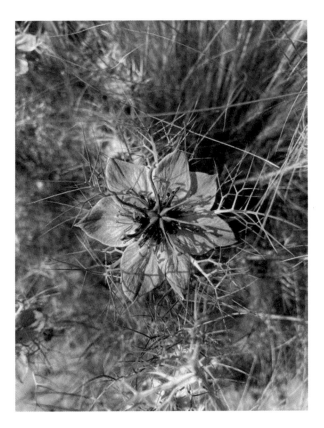

NATURAL PEACE

Within me is natural peace,
like the ease of a growing stem
that cannot be fragmented.
Within me is a natural peace, positive and powerful,
helping me persist with calm toward what is next.

PERSONAL PEACE

Nature gives me personal peace
and shows me how to persist.
I release anxiety and worry
and invite in what helps me grow.

LETTING GO

I'm letting go of you, anxiety.
I'm letting go so I can grow.
I'm letting go so I can plant
calmness in my mind and body.
I'm letting go of you, anxiety.
I'm letting go so I can grow.

Unfurling Serenity

Imagine yourself as a tightly coiled new leaf.
If your heart is beating rapidly, be mindful of its pace,
and with every breath allow it to slow down.

Give yourself permission to rest for a moment. If any tension
lingers in your body, release it with a deep, cleansing breath.
Continue to imagine you are a new leaf, and begin to unfurl.

As you breathe in, let your mind and body loosen.
As you breathe out, let your breath flow back into nature.
Continue to visualize how a leaf slowly opens.

With water, light, and time, a leaf reveals its full self.
You can too. Absorb the freedom of this transition
from tightly wound to strong and secure,
spreading into empty space unconcerned.

As the veins of the unfolding leaf stretch out from its coiled
beginnings, feel your breath stretch out into your body,
to your fingers and toes. Allow yourself to breathe out
unwanted feelings, replacing any tension with calm.

Every breath in welcomes you to a fresh start,
unfurling serenity inside you. Worry and fear are swept up and
sent away with your exhale. Extend your breath into your being.
Open up to what is good and hopeful.

Eucalyptus

Inhale a cleansing breath and let it go
slowly back into nature. Let your thoughts be placid,
and enjoy the act of being in the present moment.

Breathe in, pause, breathe out,
and switch on your imagination. You're about to enter
a sunny plant shop filled with restorative energy.

Opening the door,
you are greeted by a bouquet of eucalyptus leaves.
Breathe in notes of mint and a hint of honey.
Nature's aromas quiet a busy mind.
Begin to walk around the shop.

The sweet scents linger in the air to comfort you.
Allow anything that troubles you to leave your mind.
Welcome in happiness.

You're drawn to a collection of small houseplants nestled on a
nearby table. Succulents a vibrant shade of teal blue catch

your eye. Let your fingers run lightly over their leaves
as you feel the soft, smooth, and spongy petals.

If a wave of unwanted anxious feelings returns,
guard your peace against the intrusion of doubt.
Intentionally turn away from worry and hypervigilance;
invite in a deep breath and the warm smell of eucalyptus.
The sights and aromas of nature fill your senses, bring clarity
to your thoughts, and infuse your actions with positivity.

Stay in this moment and enjoy how
everything in your presence is alive.
Let the healing power of plants protect you.

Breathe in restful feelings, pause, and breathe out.
Remember you can return to this experience in your
memory and refocus on what is green and growing.

Release to Grow

Breathe in slowly and evenly, then out slowly and evenly.
Continue the calm exchange of breathing in and out.
When you're ready, breathe and count with me.
If unwanted thoughts arise, stay present and count mindfully.

Count: one, two, three, four, five . . . pause.
Like a caladium bulb breaking through the soil,
feel yourself begin to break free from anxiety
and doubt to unearth your inner peace.

Six, seven, eight, nine, ten . . . pause.
As a bulb secures its roots farther into the dirt,
secure yourself with a positive mindset to feel
well planted, safe, and resilient.

Eleven, twelve, thirteen, fourteen, fifteen . . . pause.
Breathe in slowly and evenly, and breathe out slowly and evenly.
See how a stem rises out of a bulb and pushes soil aside.
Imagine how you can rise up from the anxiety that holds you down.
Continue to count slowly and evenly with mindful attention.

Sixteen, seventeen, eighteen, nineteen, twenty . . . pause.
Like a plant that grows from its confined beginnings,
you can grow beyond feeling cramped or limited.
You have the tools to count on yourself to regain calm.

Twenty-one, twenty-two, twenty-three, twenty-four, twenty-five . . .
pause. Again, breathe in and out. Stay in this moment,
feeling confident in your ability to better control anxiety,
release it, and grow well.

RELEASE ANXIETY

Let's practice a simple way to release anxiety by mindfully engaging with our bodies and nature.

- Start by rolling your shoulders up, back, and down. Standing tall and straight like a tree will help slow and deepen your breathing.

- Breathe in, pause, and breathe out slowly and evenly. Visualize a tree in your mind, or look at one that is currently in your view. Focus on the tree trunk—strong, sturdy, and growing upward toward the sky. Imagine you are this tree. Feel your posture stretch and elongate. This nature-centered posture check is a useful tool to trigger a sense of personal control and help avert the onset of anxiety.

- Now relax your body from this alignment. Feel where your shoulders, chest, and abdomen are now. Are you hunched over, or do you still mimic a straighter line? Understanding your baseline posture will help you to improve it.

- Once more, mirror the stature of a well-grown tree. Roll your shoulders up, back, and down, then hold that position. This is a mindful moment that can help you release anxiety, encourage confidence, and support positive mental health.

CHAPTER 14

RELATIONSHIPS

RELATIONSHIPS AT THEIR BEST CAN BE THE most fulfilling experiences in our human existence, and while some relationships are certainly easier to navigate than others, they all take work. Here again, we have much to learn from nature. Plants teach us that in order to persist, we must be willing to grow and adapt. When we reflect the resilience of nature, we are better prepared to respond well to incoming stressors in relationships.

Imagine a group of houseplants placed closely together on a small table. A large peace lily and small pothos must continue to grow well while making room for a recently propagated monstera cutting. When the monstera begins to grow, sending out a multitude of new leaves, it causes the other plants to grow in different directions to accommodate the newcomer. Each plant must make adjustments to create a sustainable relationship for all to flourish.

In our own relationships, we must be open to bending to the needs of others. This is easier to do when we are in tune with the collaborative ecosystem of nature. A mindful connection with the natural world can calm our emotions, clear our minds, and expand our views to let us see life from multiple perspectives. With thoughtful awareness, we can find a path forward to continue a relationship, or we can pursue a respectful way to let go.

The easiest human relationships to maintain are like perennial plants. Both can seem like less work, not requiring constant maintenance. Daisies are perennials that bloom in summer, dry up and lie dormant over the winter, then come back to bloom when the summer's warmth returns once again. With durable root systems, perennial plants are well-equipped to tolerate challenges. Relationships can also stay strong, season after season, if they have a sturdy foundation.

WHEN WE PLANT SEEDS OF POSITIVITY AND UNDERSTANDING IN OUR RELATIONSHIPS, WE CREATE AN OPENING FOR COMPASSIONATE CONVERSATIONS AND OUTCOMES.

By contrast, annual plants, such as snapdragons and ranunculus, show off throughout their season, but they have end dates. Like annual plants, some relationships can be spectacular for months; we appreciate the flowers they yield, and when they end, we are left to cherish the memory of how brilliantly they bloomed.

During trying times in relationships, we can continue to turn to

plants and nature for resilience and the will to persist with positive intention. Removing ourselves from what troubles our mind and connecting to nature for a wellness break allows us to better return to a relationship with compassion for others and ourselves.

Our relationships are multifaceted, unique to everyone, and colored by where we are in time and place. Still, all relationships share some constant themes, and we can work through them with grace and persistence by maintaining our conscious connection to nature.

When we plant seeds of positivity and understanding in our relationships, we create an opening for compassionate conversations and outcomes. Sometimes tension may be reduced by humor, shared experiences, or simply the act of being present for another person.

The following affirmations, meditations, and how-tos will help us be present and grow beneficial, thriving relationships.

BLOOMING

I can be strong and delicate,
willful and watery,
blooming with kindness for others
and kindness for myself.

I CAN

I can grow in love with others.
I can practice patience through
seasons of stillness and growth.

LIKE RAIN

I watch how rain renews
the plants around me.
I seek to be like rain and embrace
my ability to renew my relationships.

Channeling Tranquility

Breathe in with trust and calm.
Breathe out, feeling softness in your mind and body.
Inhale, pause, and exhale.

Imagine a plant with silky leaves before you.
Reflect on its texture—never rough or sharp-edged,
always smooth and welcoming.

As you imagine these leaves, release any harsh thoughts
that might linger in your mind, finding harmony
in this moment with your breath and nature.

Imagine touching the plant's soft leaves;
channel this tranquility. Allow your thoughts
to be open, effortless, and serene.

Now bring to mind a relationship that challenges your calm
and triggers you to react in a rigid manner. Continue to think of
that relationship while breathing slowly in and out.

Let nature in, and with nonjudgmental awareness,
imagine responding with kindness.

Reflect the natural flexibility of plant life.
Respond thoughtfully. Act with kindness.
Speak with a good nature, calmness, and care.

The Mindful Plant

Take a deep breath in, then slowly and evenly release it.

Visualize how elements of nature communicate with each other.
A plant that senses when to bend fits in well with others.
It reads cues and is open to change.
Become the plant that feels comfortable changing course.

Breathe in slowly and evenly, then out slowly and evenly.

Imagine how a plant is aware of its space:
where it is and where it has room to roam on other paths.
Consider the freedom found in a shift in direction, the calm
unveiled in compromise that encourages growth.

Breathe in slowly, and then breathe out slowly and evenly.

Stay mindful of how the natural world constantly interacts.
Appreciate the value of good communication.
Become the plant that can share nutrients, coexist in peace,
and not view another's progress as competition.

Breathe in slowly, and then breathe out slowly and evenly.

Become the plant that acts mindfully,
connects, and bends to benefit positive relationships.
Continue to focus on your breath, and feel yourself ready
to persist and grow well with others.

Roots of Respect

Bring to mind the word *respect*. Let it sit with you.
Breathe in, pause, and breathe out slowly.
Begin to absorb the feelings of comfort and ease that
develop from a respectful relationship.

Imagine yourself walking through a botanical garden.
You are glad to be here to explore diverse nature.
With respect for the nature in your presence, you stay on the path
created for people to connect with and observe plants.

The path you walk has places where you could step off
and get closer to the stunning tropical plant life. Yet you mind
the barriers set between you and nature. You respect the space
created for plants and the space
designed for you to interact with them.

Return to your breath. Breathe in, pause, and breathe out.
Now begin to visualize a dirt path made for people to respectfully
enter an old-growth forest. The path, only three feet wide,
feels narrow and makes you want to veer off course.

Again, you could choose to experience this nature in another way—
set your own course through nature's home. But with deference
for the plants that live on the forest floor, you continue on the path.

Consider how respect is displayed in your own relationships.
See how setting paths for personal space
and boundaries can help relationships
persist and grow well.

Take another cleansing breath in, and keep in mind
respectful relationships with people and nature.
Breathe out, and appreciate the value
of honoring the needs of others.

Reaching Further

Feeling centered and calm,
visualize the stem of a plant,
like one of a philodendron that has grown very long,
completely stretched out from its base
and vulnerable to gravity.

Imagine what it's like to stretch out unprotected,
beyond what feels safe.
Now imagine how reaching out can set off
feelings of unease and increase your possibility of rejection.

Continue connecting with the image of a long stem
extending out from a plant, and the fortitude needed to
put yourself out there. Stay in this moment of self-reflection
while focusing on the internal strength of a plant to reach out
past what feels most comfortable.

If feelings of rejection take root, reframe your fears
and move away from self-criticism and negative self-talk.

Breathe in with positivity and self-assurance.
Breathe out with confidence to manage incoming uncertainty.
Stay persistent for the benefit of your mind, body, and relationships.

Now visualize a tree branch that has taken a different path
from other limbs. It grew out horizontally and is exposed
to more sunlight, creating an opportunity for great growth.
Yet because of how this branch grew, it could be
damaged in rough weather.

With this branch in mind, return your attention to yourself.
When you intentionally put yourself out there, you become
less guarded and may need to weather strong storms.
Still, you welcome the opportunity for greater growth.

Visualize yourself reaching out like a brawny branch.
Know that you can return to this moment
when you need courage to express
vulnerability and continue to grow.

STAY MINDFUL IN RELATIONSHIPS

Let's practice identifying different types of relationships through an exercise of identifying perennial and annual plants.

- Venture outside to a place like a park or garden where you can locate a variety of plants or look at a plant catalog. Bring your attention to the present moment, and focus on breathing slowly in and slowly out.

- First, identify a perennial plant, one that returns year after year like a rose, rhododendron, lilac, bleeding heart, or daylily. Stay focused on the plant you choose, and think about one of your lasting relationships that blooms year after year. Repeat to yourself the name of this person, and send them mindful thoughts of gratitude.

- Now identify an annual plant, one that was recently planted to bloom during the present season, such as a geranium, petunia, larkspur, cornflower, or marigold. While you focus on this plant, think about one of your relationships that was memorable but fleeting. Repeat to yourself the name of this person, and send them mindful thoughts of gratitude.

- Continue to identify perennial and annual plants, and connect these plants to relationships in your life. Feel gratitude for the value and nature of each.

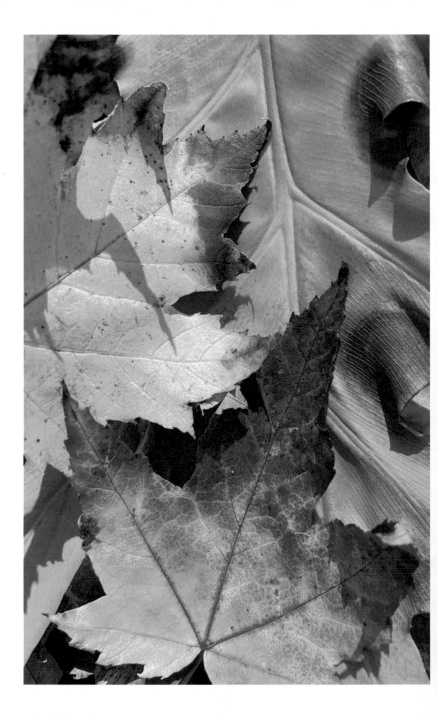

CHAPTER 15

STRESS

LET'S SAY IT TOGETHER: "BREATHE IN NATURE and breathe out stress." Our instinctual bond with nature can have a positive influence on our minds, help us manage stress, and support our well-being. Think about a time in the natural world when you felt stress leave your mind or your body. Maybe it was during a planned vacation where you could be fully present and feel your shoulders release the tension you hadn't even realized they'd been holding. It could be a moment looking out your office window onto greenery, or while driving on a road surrounded by nature as your flurry of anxious thoughts went quiet for a while. For me, a visceral moment of stress release happens during visits to city parks in autumn when the trees turn crimson.

In these experiences, connecting with nature helps reduce our levels of the stress hormones adrenaline and cortisol. And since

stress is a trigger for anxiety, contact with nature has a restorative effect on our mental well-being and can help us better handle life's day-to-day demands.

We all feel and process stressors differently, so to better manage their impact, take a moment right now and ask yourself: *What are my signs of stress? How do I express stress? Do I get angry or irritable? Do I get a stomachache, headache, or tension in my shoulders or neck? Do I ruminate and worry? Do I scroll on my phone or have trouble sleeping?*

When you identify your stress signals and know what to look out

for, you can start to manage your reactions and identify what's triggering them. Stress is ignited by external life circumstances or small daily hassles, referred to as stressors. They can be associated with high-pressure situations, nuances in relationships, pressures at work, or health issues that feel demanding, challenging, or threatening.

Let your mind bring to light some of your stressors. And as you build an understanding of where your stress is coming from, you can develop ways to deal with your stressors. Practicing

TURN TO THE SUN

nature-centered mindfulness gives you the tools to increase your awareness of what's going on in your mind. Stepping back for a moment allows you to be an objective observer. This way, you're not too attached to whatever thoughts or feelings are passing through, including stressful ones. Instead, you can be fully in the moment without judging the situation, yourself, or others.

NATURE CAN HELP HEAL AND PROTECT YOU FROM THE HARMFUL EFFECTS OF STRESS.

By adding nature-centered mindful movements, you can be less distracted, more focused, and finely attuned to what is happening now. In many ways, nature can help heal and protect you from the harmful effects of stress.

Join me for the next nature-centered affirmations, meditations, and how-tos that help grow healthy habits you can rely on when you need them most.

MOMENTUM

When I feel stress,
I pause and acknowledge
challenging thoughts and feelings.
Then I breathe in and out calmly
to regain the momentum to grow forward.

IN RESPONSE

Nature shows me ways to respond to stressors.
I can't avoid all stress, but I can
better manage my response.

HOLD ON

Stress can make me feel like a delicate
piece of nature in a relentless downpour.

But I know even fragile flowers in a deep
soak are able to hold on and persist.

Plant Problems

Imagine you've just returned from a long vacation.
With that relaxed feeling in mind,
breathe in and breathe out.

In a moment, you'll check on your houseplants.
It's midsummer, and the weather is warm and humid.
During these months, you place your houseplants
outside to soak up the season, and you're hoping
the heat has been kind.

Though you drenched each pot well before leaving,
you see that most have dried out while you were away.

You hoped for rain that never arrived,
and one particular plant has very droopy
leaves and isn't doing well.

This is a sign of plant stress, but you know what to do.

You pull the planter back into the shade and give it
a good drink. Now you'll remember that
more shade and less sun is a better plan for this plant.

Just as you identify the stress symptoms of a plant,
you are learning to be aware of and better understand
your personal stress signs and triggers. With intention,
you can gain awareness and calm your stress response.

Take a moment and bring to mind one cause
of stress in your life. Focus on it without judgment
while taking slow, even breaths.

Visualize controlling your reaction to this
stress and charting a course beyond it.

Growing in nature-centered,
nonjudgmental awareness can help de-escalate
and rewrite your reactions to stress. As you practice
noticing how stress manifests itself, you can also
practice living in the present moment.

With this approachable path to better manage stress,
take a slow, even breath in, then pause. Now, filled with
reassurance, breathe out.

Dandelion Dancer

Breathe slowly and evenly, in and out.
With each breath, feel stress soar away
from your mind and body.

Focus on the image of a dandelion
that's turned from a palette of yellow
petals to white, fluffy seeds.

In this stage of the dandelion life cycle,
the seeds are nearly ready to take flight,
carried by the wind, up and away.

Paint the image of a dandelion in your mind.
See the white, cottonlike seeds that
ever-so-lightly cling to the stalk.

Visualize yourself bending down
to pick this dandelion from the ground,
then stand up and hold it about a foot from your face.

Notice the details of the seeds.
Twirl the stem in your hand.
Create a movie of it in your mind.

Breathe in, pause,
take an extra sip of air,
and enthusiastically exhale.

See your breath meet the dandelion seeds.
Watch closely as they detach and fly away from you.

Fully engage your imagination as you rest at the bottom
of the exhale and follow the seeds into the distance.
Then repeat.

With each breath, you imagine the dandelion
generating a new batch of seeds that bend
to your breath and fly away.

Breathe in and pause, take an extra sip of air,
and reset this image. Then breathe out, and let the seeds sail.
Imagine blowing away stress with each mindful breath.

The Dunes

Breathe in nature; breathe out stress.

Let your mind travel to the seashore, focusing
on an image of dune grass at a wide-open beach.
Notice how it grows in groups atop undulating dunes
that line the beach like a lazy river.

Soon, a powerful wind washes over the dunes.
The slender grass flutters with agile elegance,
holding fast to the sand it was planted in to protect.

As the green stalks sway with resilience,
your body starts to feel calmer, more flexible.

Thoughts or feelings that pulled tight
on your mind, creating stress, begin to loosen.

Notice how you're adopting the anchored
but adaptable qualities of the grass at the shore.
Life stressors can present themselves as wild wind,
but you can persist like the fluid, grassy dune.

Remember that you can connect with nature
and release stress anytime, anywhere.

In this moment, breathe in deeply,
pause at the top of your inhale,
then let your breath out slowly and evenly.

Storms of Persistence

Imagine you see a storm approaching.
A deep charcoal sky rumbles overhead.

Your body registers a jolt of adrenaline for what is unpredictable.
The unknown. You've felt this before.
Breathe in and breathe out.

See your new flowers and plants growing outside.
They look lively, and the leaves are perky.

But as the sky opens and an aggressive cloudburst
releases marble-size droplets, you know this storm
will challenge them.

You watch as the leaves show their flexibility,
tilting from side to side like the wings of a fighter jet.

You hear the rain roar in with fierce energy.
But just like storms in your own life, eventually
the droplets become smaller, less intense.

The sky changes into a watercolor
of light gray with blue splashes.

The storm is over. Nature persists. You can too.
Breathe in, pause, and breathe out.

RELEASE STRESS

Let's practice releasing stress through nature-centered, mindful movements that focus on our feet. Getting out of your head and engaging your feet creates the opportunity to break free of ruminating thoughts and feelings that build up to create stress.

- Sit outside and place your feet on a surface other than grass, or stay seated inside.

- Let your mind transform the floor below you into a large patch of lush green grass. Plant your feet securely on the surface. Apply a little pressure, then pause to notice any sensations in the heel and ball of each foot.

- Now allow your mind to relax as you imagine your bare feet in the silky grass. Stay focused on the sensation of grass beneath your feet.

- Start to wiggle your toes. Then isolate the movement. Move your left toes and then your right toes.

- Pause and rest your feet on the imagined grass. They feel steady and rooted. You are grounded and secure. Breathe in and breathe out. Start to move your toes again as you continue to breathe in nature and breathe out stress.

- Visualize releasing tension and letting it go out from your toes and into the earth. Then rest and press your feet firmly on the ground. You are grounded and secure.

CHAPTER 16

CHANGE

THERE IS COMFORT IN CONSISTENCY. BUT just because an aspect of life is consistent doesn't mean it's always good. If something is not going right—even if it looks fine from the external perspective, but you know in your gut that something is off—allow yourself to feel capable of embracing change. If our life changes could be scheduled like the changing seasons, then maybe we wouldn't feel as much pressure or stigma around the notion of change. We could enjoy and be thankful for changes that help us get unstuck and reset without the fear and anxiety that creep in when we look into the unknown.

When seasons change with the tilt of the earth's axis, the nature around us receives either more or less sunlight, warmth, and water. The natural world has to adjust to these changes. Leaves on deciduous trees respond by changing color and falling to the

ground, providing natural mulch that feeds the tree's roots. When spring comes, branches that were dark and bare against the sky start to bud.

These seasonal changes in nature are visible testaments to our inherent hope that positive change is possible. When we are aware that something in our presence is evolving, those changes can be contagious, not threatening. Focusing on hopeful changes in natural surroundings can relieve unwanted feelings, bring calm into our lives, and help us connect to the earth, ourselves, and the progression of time—both in the natural world and in the stages of our inner lives.

Consider examples of changes in nature. From small ones, like a stem growing a new leaf, to bigger changes, like a large tree limb falling off during a storm or a hilltop cloaked in the rich amber of autumn, change doesn't wait to be granted permission. It just happens. Nature illustrates this with perennial consistency.

WE HAVE A CHOICE: TO RESIST CHANGE OUT OF FEAR OR TO PRESS TOWARD IT WITH THE COURAGE TO GROW.

One afternoon, a new leaf on a potted plant might be tightly coiled. By the following morning, it could be fully unfurled, thrumming with life and promise. This bold and quickly realized difference is evidence of the sizable changes we can personally make.

Changes on our planet and in our own lives are inevitable,

sometimes difficult, and almost always rewarding in some way. When we align ourselves with the natural oscillation of change and stay in tune to the wider natural world, we can change our outlook and adjust our responses. By taking a favorable approach to change and connecting it to growth, we can pave a welcoming path to move forward.

Before we go into our affirmations, meditations, and how-tos, challenge yourself to dig in and review aspects of your life that pose the opportunity for productive change. Consider what could be helped by a slight shift or revision. Change is ceaseless, perpetually rolling in like the tide and sending out ripples into our lives. As new seasons arise, washing in and out with the pull of the moon, we have a choice: to resist change out of fear or to press toward it with the courage to grow.

FIRST FROST

Like the first frost in fall,
change can set me off course.
Yet the more secure I feel in my center,
the better I can weather change and persist.

WILLOW'S WIND

I'm a willow tree in the wind of change.
I've learned to sway with turbulence.
Because I know when the gale passes by,
I will still be standing, grounded in the present.

DIG BACK IN

Like a plant that's lost some roots,
I can come loose from my foundation.
But I embrace this change and dig back in
to grow well.

Trajectory for Change

With the anticipation and excitement of change in mind,
breathe in, pause, and extend your exhale.

Imagine you're holding a calendar with nature photography.
A spiral wire keeps the glossy pages together.
Flip through the months, one after the other.
See how nature changes with the seasons.

Now visualize being in a temperate climate
where the natural world shows off the progression
from month to month. See the warm colors of autumn,
the chill of winter, and the splendor of spring.

The natural world displays a trajectory for change,
and each day you're given a chance to follow it and feel
connected to the optimism of an approaching season.

With an ever-changing landscape,
you can paint your life across nature's canvas
and see the pragmatic potential of change.
This continuum of newness excites you.
A fresh start with the seasons feels good.
Breathe in, pause, and breathe out slowly and evenly.

The Bliss of Perspective

Perspective influences the way you deal with change.
Breathe in to clear your mind, then breathe out
with a long, calming exhale.

To help shape a broader perspective,
imagine you are on an expansive walkway
by a metropolitan waterfront that connects
city life to an energetic body of water.

You're greeted with a pleasing green area.
It runs down the middle of a sturdy pier
that juts out far into the river to meet
the billowing waves.

To your left, water rushes under the pier.
To your right, clusters of trees dot the runway of grass.
In this moment, the thoughts that occupied your mind
give way to the intrigue of your changing surroundings.

See yourself nearing the end of the pier.
Trees, small ground cover, and bushy shrubs
replace the harsh lines of the city.

Pause to take in a deep breath and feel the air
that sails above the waves enter your lungs.
Looking out to the water, you are refreshed.

The trials of the day are whisked away
with the foliage and fast-moving water.
Your body is light and free.

You feel blissfully "changed"
as you separate from the city
and connect with the natural world.

The contrast in scenery from rows of buildings
to an expansive natural backdrop feels renewing.
Change takes effort, but at this moment its value is clear.
You respect how change provides a shift in perspective.

Now, with a cleansing breath in and out,
come back to where you are.

Whirlwind

Picture a beautiful weather day.
The wind is light and barely bothersome.
A few fluffy clouds speckle the sky
over a wide landscape of restful greenery.

Today feels ordinary; the calmness of the
consistent scene soothes you.
Stay with this image.

Take a cleansing breath in, pause,
and enjoy a long, relaxing exhale.

If you gaze to the right, the scene appears unchanged.
To your left, the sky quickly transforms to navy blue.
A new weather front is approaching, carried in by a mounting
breeze and the low murmur of rumbling air.

Like a race car barreling down the straightaway,
a frantic burst of wind flies past you. And then another.
As you witness nature confronted by a whirlwind of weather,
the trees and plants twist and turn in the sudden commotion.

Lightweight leaves flutter back and forth like waving flags.
What moments ago was a placid and peaceful day
has changed into a torrent of unexpected fury.
You watch as the natural world's innate flexibility
protects it from harm.

There's a roof overhang just behind you.
Step under it and stay present. Watch how nature
molds to challenging circumstances and persists.

Let nature inspire your own ability to weather storms.
When thunderous clouds approach and the torrential rains
of change pool at your feet, you can confidently persist and
carry on, breathing in and out.

The Trek

As you breathe in nature and breathe out stress,
guide your breath to flow slowly and evenly in and out.

Continue to engage with the cadence of your breath,
and feel the intentional positive change you can
create in your mind and body.

Now imagine that you're about to embrace a big change—
one that will challenge your ability to persist but
offers a significant life experience.

You've been invited to trek across a famed mountain range
with long-distance hiking trails interspersed with shorter routes.
You pick a shorter adventure that still stretches
you far from your norm.

Feeling slightly uneasy about the unknown,
you head off on the trail before inner
hesitation sets in to stop you.

Change can feel like an unnavigable precipice,
but with mindful awareness and presence you can persist,
and what was intimidating can become exhilarating.

See yourself taking long strides as you traverse
the contrasting landscape from an expanse of
blue thistle and purple iris to high, rocky ridges.

When you reach a tall peak, look down to the carved-out,
deep valley below and the still-as-stone,
sapphire-blue lake.

The sight of fellow travelers in the distance,
who followed the same path, helps boost
your confidence in this journey.

Pause here. Breathe it all in, and then breathe out.
Change and new experiences take courage,
but the rewards can be grand.

CREATE POSITIVE CHANGE

Let's practice the positivity of change by embodying plant stems. With this simple practice, you can enhance your posture to benefit your body and mindset.

- Find a plant stem outside, see an example in your houseplants, or look up a visual image online. Pay attention to how stems elongate, seek growth, and stretch tall to support leaves or flowers. If you can pick a flower or plant leaf and take it home, place the stem in a glass vase as a visual reminder.

- Begin to personify that shape in your human frame. Align your spine to match its statuesque position.

- Breathe in and breathe out. By straightening your posture and stretching your torso, you can breathe more freely from your dia-phragm. Imagine how it feels to be a plant stem. Hold this position for ten seconds, then release.

- Keeping nature as your guide, repeat this posture position and breathing pattern whenever you want a quick, natural reset.

A mindful posture check is a physical reset to help change old habits and patterns and realign your path.

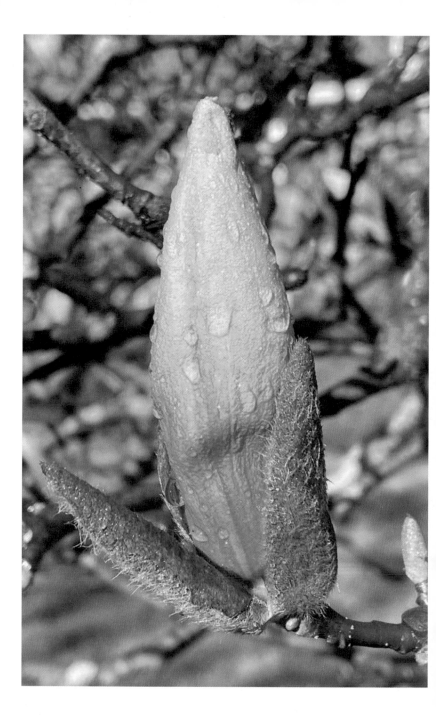

CONCLUSION

GROWING FORWARD

THANK YOU FOR JOINING ME ON THIS JOURney to release stress and grow well with the natural world. Together we have invested in our present and future selves by giving the needed presence, focus, and energy to mindfully establish strong roots that will support our mental, emotional, and physical health. This sturdy root system won't restrict where we can grow next. Instead, it forms a solid footing for growing forward.

Connecting in a contemplative way with nature helps you construct a sound foundation of self-appreciation, internal calm, and compassion—a symbiotic relationship that will continue to flourish and champion your growth. As you stretch beyond your current experience, you may encounter moments of unease. Keep nature close and ever-present in your thoughts, and keep a positive outlook to help you push through.

This consistent stream of positivity isn't to trick your mind into believing all things are wonderful all the time. Positivity doesn't set you up to live outside reality, but it does highlight what is currently good in yourself and your life. You've seen in this book how nature excels at sharing positive displays, and the natural world will forever be ready to support you. Even if nature is physically far away, by practicing mindfulness, you can always create space in your thoughts to bring waterfalls, forests, oceans, trees, and plants close to you. When you return to the affirmations, meditations, and how-tos in this book, you can feel the positivity of being close to plants.

While the future rests on the horizon, we can know that the progression of ever-unfurling seasons will allow you to boldly bloom or to hold tight until spring returns. By using the tools you've practiced on our journey, I know you have grown to be better prepared to meet the evolving demands around you with confidence and calm.

Anytime you feel yourself in a moment of need, remember that plants effortlessly project a captivating combination of energy and stillness for the benefit of all who pause to be present with them and receive their gifts. And I'll be cheering you on as you mindfully connect, feel nourished, grow, and persist with nature.

> Growing forward in this mindful moment,
> let's breathe in slowly and evenly, pause,
> and breathe out slowly and evenly.

ACKNOWLEDGMENTS

A GARDEN BECOMES GLORIOUS WHEN MANY different elements come together to help it grow well. Our lives flourish in the same way, and I've been fortunate to have special people and places that helped me and this book to bloom.

Thank you to Marnie Blount-Gowan and Bill Gowan, the bedrock of my life; to Trevor Gowan, my brother, best friend, and perennial cheerleader; to the mature generation of ladies with wildflower spirits who took turns nurturing me—Dorothy Blount (Grammy), Aunt Peggy, Olive MacKenzie, and Cynthia Adler; to my beautiful bouquet of lifelong friends; to my agent, Alexandra Levick, who believed in me when this book was just a sprout of an idea; to the nourishing team at Celebrate for taking good care of and enthusiastically championing my vision. And to New York City, for without you I wouldn't have experienced nature in a way that transformed my life.

ABOUT THE AUTHOR

B RITTANY GOWAN is a stress management coach, photographer, and the creator of Pause with Plants. Nature is central to both her coaching practice and her approach to meditative art, inspiring care for both people and the planet. She holds an MS in psychology and an executive coaching certification. Brittany lives in New York City, and you can likely find her in the Gardens at St. Luke's in the West Village.